WANDERING
WICKLOW

with Father Browne

Edited by Robert O'Byrne

Published by Messenger Publications, 2020

ISBN 9781788122689

Father Browne SJ prints are available from
Davison and Associates, 69b Heather Road, Sandyford Industrial Estate, Dublin 18, Ireland
www.fatherbrowne.com

Designed by Messenger Publications Design Department
Typeset in Bernhard Modern & Garamond Premier
Printed by Hussar Books

Messenger Publications,
37 Leeson Place, Dublin D02 E5V0
www.messenger.ie

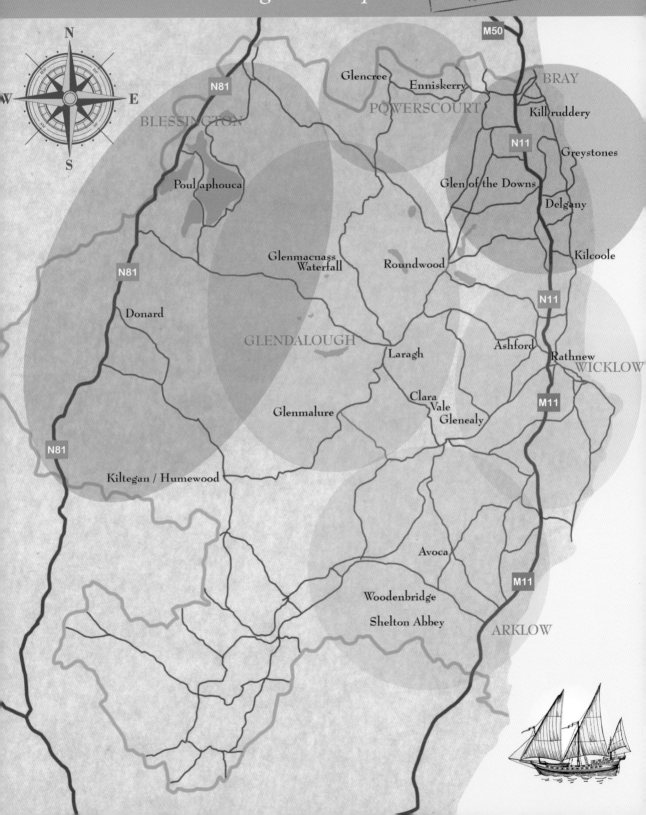

WICKLOW
a guide map

N
W E
S

M50

N81

Glencree

Enniskerry

BRAY

POWERSCOURT

Kill ruddery

BLESSINGTON

N11

Greystones

Poul aphouca

Glen of the Downs

Delgany

Glenmacnass
Waterfall

Roundwood

Kilcoole

N81

N11

Donard

GLENDALOUGH

Ashford

Laragh

Rathnew

WICKLOW

Clara
Vale
Glenealy

M11

Glenmalure

N81

Kiltegan / Humewood

Avoca

M11

Woodenbridge

Shelton Abbey

ARKLOW

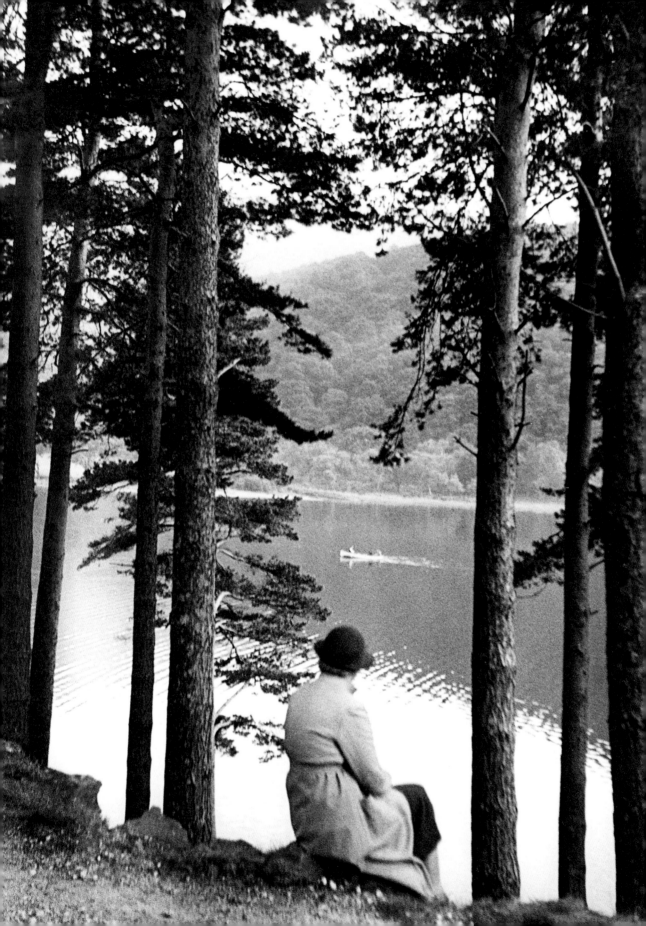

CONTENTS

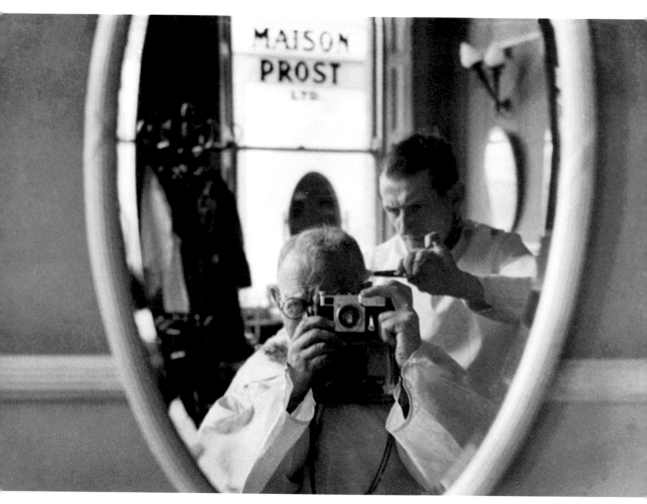

Father Browne taking a 'selfie'

Wandering Wicklow with Father Browne

An Introduction

Now recognised as Ireland's finest photographer during the first half of the last century, Frank Browne perceived the medium that brought him posthumous fame primarily as a hobby. He spent the greater part of his life a member of the Jesuit order, and his religious faith and work as a priest needs to be understood when considering his photographic legacy.

The youngest of eight children, Francis Patrick Mary Browne was born in Cork city in January 1880, his parents being members of the country's newly affluent Catholic bourgeoisie. But wealth is no guarantee of health and within a week of being born, he lost his mother to puerperal fever. After primary school, the young Francis attended first the Jesuit-run Belvedere College as a day pupil, and then boarded with the Vincentian Fathers at Castleknock College, both in Dublin. His earliest photographic attempts came in 1897 when, accompanied by an older brother, he travelled through France, Italy, Switzerland and Germany. The pictures he took on this trip are those of a tourist, but already there is evidence of the eye for composition that would later be refined.

On returning to Ireland, and still aged only 17, Francis Browne entered the Society of Jesus novitiate in Tullabeg, County Offaly. On arrival, he was obliged to hand over his camera since it was regarded as a 'superfluity' and a distraction from his preparation for the priesthood. Even though he subsequently moved to Dublin to study at University College, several more years would pass before he was permitted to take photographs again. This only occurred in 1902 when he was sent to a Jesuit house in the Italian town of Chieri, southwest of Turin. During the summer months of this period, he was able to travel around the country, staying in properties belonging to the order and improving his skills with a camera, not difficult in such a photogenic part of the world. He also had an opportunity to visit many museums and art galleries,

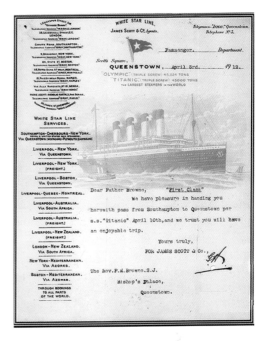

absorbing ideas on composition from Old Master paintings.

Back in Ireland in 1905, Frank Browne was sent to teach in Belvedere College, the secondary school where he had once studied and where he would spend the next five years. During the first of these he put his photographic abilities to use by founding a camera club (as well as a cycling club and a college annual, *The Belvederian* in which some of his pictures were published). For the next stage of his training, he moved to another Jesuit house, Milltown Park on the outskirts of Dublin.

It was while here that he received a gift from his uncle Robert Browne, Bishop of Cloyne: a ticket to travel on the first two legs of the maiden voyage of a new liner, the *Titanic*. As is well-known, he boarded the vessel at Southampton on 10 April 1912 and sailed first to Cherbourg, where more passengers

were collected, and then to Queenstown (now Cobh), County Cork, the *Titanic*'s last stop before crossing the Atlantic. While on board, Frank Browne had become friendly with an American family who offered to pay his fare for the remaining part of the voyage. A message was sent to the Provincial Superior of the Jesuits in Ireland asking if this might be allowed. On arrival at Queenstown, a reply awaited. It read 'GET OFF THAT SHIP – PROVINCIAL'.

The young man dutifully disembarked, with his camera, and the *Titanic* sailed to its doom. After the vessel sank on 15 April, the photographs Frank Browne had taken while on board were much in demand, published in newspapers around the world. They remain invaluable historical documents and have helped to secure his lasting fame. Had he intended to become a professional photographer the *Titanic* pictures would have been of considerable help in advancing his career, but Frank Browne was intent on being a Jesuit priest, finally realising this ambition in July 1915. The following February he became a chaplain to the First Battalion of the Irish Guards, serving in that capacity first on the front line in France and Flanders until November 1918 and then in Germany for another 18 months. Although gassed once and injured five times (on one occasion needing to have his jaw wired up), he survived this gruelling period, continuing to take photographs which, like those of the *Titanic*, are today of immense historic interest.

Nothing during the second half of his long life brought Father Browne back to the centre of global events, but it was nevertheless a time filled with activities that were of importance to him. Having once more spent time teaching in Belvedere College, he became Superior of St Francis Xavier's Church on nearby Gardiner Street where he enjoyed renown as a preacher. Then in 1928 he was assigned to the Mission and Retreat staff of the Jesuit order, a position he held for the next 30 years. While based at Emo Court, a late eighteenth-century country house in County Laois, which the Jesuits had just acquired, he was required to travel throughout Ireland, and often to England, holding parish missions and leading retreats for nuns, other priests and children.

Much of his work took place in the evenings, leaving him free during the day to explore – and photograph – his immediate surroundings. Father Browne took full advantage of these opportunities and, as his substantial archive reveals, little escaped his attention. This is what makes the collection he left behind so valuable: it documents all aspects of daily life across some 50 years although, as has been noted by other commentators, there is one notable lacuna in this visual narrative: there are no pictures of public house interiors.

In 1957, three years before his death, Father Browne was transferred from Emo Court, his home for the previous three decades, back to Milltown Park, Dublin. While there, he catalogued his immense collection of photographs, by now running to some 42,000 negatives, providing names and dates for them all, documentation that has proven invaluable when compiling books of his work such as the present one. He died aged 80 in July 1960.

This brief summary of Father Frank Browne's life is necessary in order to emphasise that its main focus was always his religious faith and his work as a Jesuit priest. Photography began, and remained, a hobby to be fitted in – and sometimes set aside – as and when was required by his superiors in the order. Having already founded a camera club while teaching at Belvedere College, he later became a member of both the Photographic Society of Ireland and the Dublin Camera Club (the two organisations would amalgamate in the early 1930s). The Dublin Camera Club had been established by William Harding, journalist and editor of a magazine called *The Camera*. In June 1927 he proposed to a group of like-minded friends, including Father Browne, that they hold an exhibition of their work: the first Irish Salon of Photography was held later that year and became a biennial event until the outbreak of the Second World War. Father Browne acted as vice-president of the show, where he exhibited his own work, for which he was awarded many prizes.

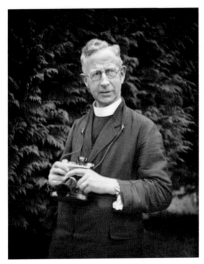

1939: *Father Browne with camera and spare lens, photographed by Father Michael Garahy*

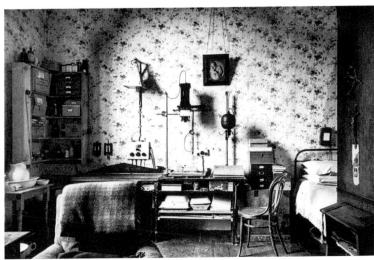

1931: *Father Browne's bedroom and photo laboratory at Emo Court*

It must be repeated, however, that photography remained an extra-curricular activity. This makes his achievement in the medium all the more impressive. One way or another, it had to be accommodated within the pre-ordained structure of Jesuit life. Browne the photographer deserves comparison with Andrea Pozzo, the seventeenth century Jesuit brother who was also a highly talented painter and architect. Fra Pozzo could have had a successful secular career as an artist, but instead chose to devote himself to the Catholic Church and in particular to the Jesuit order for which he executed his greatest works. Not the least of these is the astonishing illusory perspective ceiling in the Church of Sant'Ignazio in Rome, which no doubt Father Browne would have seen on one of his visits to the city. He would have known of Fra Pozzo and like him, would have followed instructions rather than his own personal wishes. Where and when he went was decided for him, and so therefore were the places he had an opportunity to photograph. Resisting the urge to follow his own wishes must always have been challenging, but especially during the 1940s and 1950s when Father Browne received many commissions for pictures. The requests came from a wide variety of individuals and organisations whether the Office of Public Works, the Irish Sugar Company or Bord na

Móna. Inevitably his services were regularly called upon by the Irish Tourism Association (an early precursor of what is now Fáilte Ireland). Even before this period, he had already achieved sufficient renown that in 1933 Kodak offered to provide him with free film for the rest of his life (one wonders whether the company expected him to live quite so long).

These assignments indicate that Father Browne could have made a living as a photographer, but chose not to do so. Furthermore, all financial compensation he received for his work, and during certain busy periods the amounts must have been substantial, he was not allowed to retain: the money was immediately forwarded to the provincial treasurer of the Jesuit order. At least he could derive some consolation from awareness that the funds were, at his own suggestion, used to assist in the education of Jesuit students by providing what he nicknamed 'Brownie Burses'.

Father Browne was a priest first and a photographer second. And yet, as the present selection of pictures demonstrates, his vocation for both was equally strong. Making a choice from among the thousands of photographs he took of County Wicklow therefore proved challenging; so many of them merited inclusion, his eye invariably alighting on the visual equivalent of the 'mot juste'. Of course, in this he was

helped by the fact that Wicklow is an exceptionally beautiful part of the country, justifiably renowned as the 'Garden of Ireland'. In addition, it offers an infinite variety of scenery, with a long sea coast on its eastern side and the great Wicklow Mountains running like a spine down its centre. It rejoices in picturesque towns, such as the port of Wicklow itself, along with the likes of Blessington and Baltinglass, Enniskerry and Ashford, together with famous beauty spots like the Meeting of the Waters and the Glen of the Downs. There are abundant antiquities, not least those found at Glendalough, as well as fine historic houses. And all of this on the doorstep of Dublin, making access easy for Father Browne, especially when he was living in the capital.

No wonder therefore that he returned to the county time and again, and that some of his earliest Irish photographs should have been taken in Wicklow. A particularly fine example from this formative period is his view of the Dargle Glen, photographed in 1910 (page 111). This part of the county has long appealed to artists, indeed there is an oil by Irish painter George Barret believed to date from the early 1760s and offering almost an identical image of the same glen. In both instances, the scene has been carefully framed by trees and a figure placed on the left-hand side in order to provide a sense of scale within the landscape of rocks, water and foliage. There's no evidence that Father Browne ever saw Barret's painting. More probably, like the artist he was attracted to the picturesque nature of the scene. And by this time, as has been mentioned, he had spent several years in Italy, visiting many of the country's galleries where pictures by landscape artists such as the seventeenth-century painter Salvator Rosa would have provided abundant inspiration for a young photographer on how best to compose his own images. This is apparent in Father Browne's picture of the Anglo-Norman Black Castle: ruins perched above the potentially turbulent waters of the Irish Sea is a prospect that would have thrilled any admirer of the picturesque.

The county's stirring variety of landscape imposed its own authority on Father Browne, as it has on artists across the centuries. Certain spots exert an irresistible draw, not least Powerscourt Waterfall,

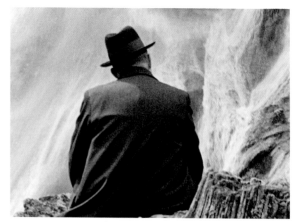

1933: *Detail from Father Browne's photograph at Powerscourt Waterfall. See page 106*

the greatest example of this natural phenomenon in Ireland. Inevitably George Barret had painted here, along with many of his contemporaries and successors. Father Browne's image (page 106) is also highly painterly, because although he places a figure in the foreground of the scene, the individual has his back to the camera, apparently gazing into the depths of the foaming waters, the diagonal folds of his coat following the undulating line of the waterfall's rocks. Had he instead been facing the photographer, the effect would have been to reduce the picture to little more than another tourist snap, just a souvenir of a visit to a popular destination. Instead, by situating the figure in isolation, Father Browne evokes memories of paintings by Caspar David Friedrich. Many of the early nineteenth-century Romantic German artist's most successful works, such as *Wanderer above a Sea of Fog* and *Woman at a Window*, similarly feature individuals or even groups turned away from the viewer, who is thus encouraged to introduce a self-created narrative into the scene. A very similar composition was employed with equal effect by the photographer for a view of the lake at Glendalough (page 119) with only the gender of the sitter being changed.

Like many painters before him, Father Browne frequently introduced the human figure, or at least evidence of human life, into his landscape pictures: it helps to provide the viewer with a sense of scale. Both the cyclist on a mountain road near Glencree

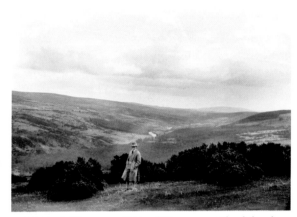

1925: A O'Leary and Vale of Clara, near Glendalough, an example of a figure giving scale to a landscape

(page 104) and the farmer with his pony and trap above Lough Tay (page 115) suggest how small and insignificant man can be compared with the grand scale of the natural environment. Only in a handful of Father Browne's photographs is humanity altogether absent, as in a view of Lugnaquilla from Drumgoff (page 126), the background a prospect of gradually receding mountains waiting to be captured on canvas by Paul Henry. In his photographs of daily life, such as an image from 1933 of two railway officials lighting cigarettes beside an advertisement for the product on the platform of Wicklow station (page 69), Father Browne has often rightly been compared with the humanist photographers Henri Cartier-Bresson and Robert Doisneau. In another picture from 1942 showing an elderly man and a young boy sitting on the edge of a boat in the harbour of Arklow (page 87) he displays a spontaneity as refreshing today as it was at the time. The whimsical delight of Doisneau's pictures of children at play can be found in Father Browne's photography as well, not least his image of two boys perched on an anchor, also taken in 1942 (page 88). But when it comes to his landscape work a more apt comparison would be with an earlier French photographer whose work is similarly infused with the spirit of Romanticism, Eugène Atget. And in his palpable love of the natural world, he displays affinities with another Jesuit, the poet Gerard Manley Hopkins. Yet while his landscape photographs unquestionably

reveal him to be a Romantic, Father Browne had no qualms about celebrating the modern world. A picture taken in 1925 of a traveller woman with a pair of children perched on a donkey (page 114) might have come from the eighteenth or nineteenth centuries, but for a motor car being visible behind them: the old and the new intertwined. From 1925 onwards cars appear in a number of the images, indicating they provided the means by which Father Browne explored much of the county, particularly more remote regions that might otherwise have been challenging to reach. Given the number of times he photographed cars, it becomes apparent that he appreciated their aesthetic qualities, recognising that on occasion their presence might enhance a picture. In 1929, for example, he took a photograph of a car parked on an otherwise deserted roadside. Facing away from the camera, it guides our eye to look afresh at a vista so familiar that it is at risk of becoming stale: the unmistakeable outline of the Sugarloaf mountain (page 44). By introducing the man-made into his composition, Father Browne provides a new observation of the natural environment.

Cars were by no means the only technological innovation recorded over the course of his long lifetime. In 1940 Father Browne, then aged 60, was able to visit the site of a dam being constructed at Poulaphouca (pages 132, 133). After Ardnacrusha, County Wicklow, this was the second big hydroelectric scheme undertaken by the new Irish state and involved damming the River Liffey to create what remains the country's largest artificial reservoir. Father Browne's photographs are a record of the construction work underway at the time and, particularly in his image of a man standing within the pipe, offer a sense of the scale of the operation. A couple of years later, he visited the Solus Teoranta bulb factory, which had been opened in Bray in 1935 by Seán Lemass, then Minister for Industry and Commerce (page 27).

Enterprises of this kind were important in the newly-established Irish state, keen to encourage modernisation and the betterment of her citizens' circumstances.

However, even while this pioneering work was occurring, much of the country continued to operate at a slower pace, performing tasks little changed for

centuries. Farmers still brought their livestock to fairs in country towns like Blessington (page 134), an opportunity both to conduct business, and to meet with neighbours and exchange news and opinions. Other rural activities also served the same purpose, such as coming together to dip the sheep (page 43). Without the telephone or the other forms of communication now taken for granted, many people still lived in relative isolation, occupying small, whitewashed cottages with just a few rooms inside. These buildings were often thatched, and their roofs needed to be maintained and repaired by traditional craftsmen (page 73) if they were to look as well as a charming example photographed by Father Browne in Rathnew (page 72).

In his travels about the county, he also recorded commercial activity of all kinds, halting to take pictures of seasonal produce such as tomatoes and mushrooms being offered for sale on the side of quiet country roads (pages 74, 75). More regulated retail ventures in the county's towns and villages are also captured, as can be seen in delightful photographs of both the façade and interior of a chemist's premises in Wicklow (pages 58, 59), as well as an interior of a millinery shop, light coming through the window to lick the outline of a new season's hats, each perched atop its stand (page 60).

Once again in his compositions, Father Browne uses light in a painterly fashion, as in a photograph of a woman hanging out washing at St Ciaran's College, Bray (page 26). The picture was taken in 1942 but an almost identical one might have been painted by a Dutch genre artist such as Adriaen van Ostade: like those old masters, Father Browne was able to locate poetry in the humdrum. The same skill was brought into play when it came to photographing buildings, where an understanding of architecture's sculptural qualities makes his pictures more than just records. A view of a dormitory in the Mercy Convent, Arklow cleverly includes an open doorway in the left foreground, thereby indicating that we are being temporarily permitted to see into a world otherwise barred to us. And indeed, there were occasions when Father Browne did record environments unfamiliar to the majority of his fellow citizens, as when he visited some of County Wicklow's great private houses. His

pictures of two of these are especially important, the first being Killruddery, ancestral home of the Brabazons, Earls of Meath. It is, of course, still owned by the family and a popular destination but what many visitors to the property may not know is that Killruddery was once considerably larger. Father Browne visited the house in 1947 and just a few years later a substantial part of the building, including its original entrance front, was demolished owing to an infestation of dry rot. Father Browne's photographs are therefore an invaluable record of the house prior to demolition.

Just as important are the pictures he took at another country house elsewhere in the county, Shelton Abbey. Today an open prison, it was for some 200 years home to the Howard family, Earls of Wicklow. When Father Browne visited for the second time in April 1947, the eighth earl was preparing to open the place to the public as a country house hotel; one wonders what Mr Virtue, Shelton Abbey's old butler photographed at the front door, must have thought of this change of circumstances (page 93). The building was then still filled with treasures accumulated by generations of the family, many of them captured in situ by Father Browne as he and his camera went from room to room. He was there in good time because the hotel venture was not a success and in 1950 Lord Wicklow was obliged to sell Shelton Abbey's contents in a spectacular auction that lasted for 13 days. The great majority of lots went to overseas buyers and left Ireland, making Father Browne's pictures priceless as a guide to how the house was originally furnished.

This is true of all the many photographs he took across several decades: they provide us with a guide to Wicklow's appearance during the first half of the last century. And, thanks to Paula Nolan's contribution, we are able to contrast how the county looked then with how it looks today. Sometimes the juxtaposition of old and new highlights how Father Browne's pictures are a record of another era. But in other instances, they demonstrate the timeless character of both his art and the places he visited in this part of the country. Like Barret and others before him, he inspires us to look afresh at the familiar as we join him, leisurely wandering through Wicklow.

Recreating the Lens of Father Browne

Paula T Nolan

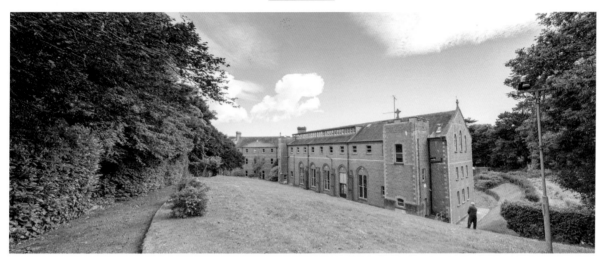

2020: *On our way to the right spot for the photograph: the steep path that runs along the side of Dominican College, Wicklow*

The journey through Wicklow with Father Browne began with a simple idea: why not recreate some of Father Browne's iconic photographs in order to show how places looked now, and how much things had changed in the ensuing decades. With Robert O'Byrne, the editor, a decision was made to recreate twenty of the ninety-two originals in this book.

For the past twelve years as art director with Messenger Publications, it has been my good fortune to design many books of Father Browne photographs – including this book – and to work extensively with the Father Browne archive. Over the years, as designer, photographer and admirer, I've become intimately familiar with the view through his lens.

And so it was, armed with my own lenses, that myself and my assistant Ruaidhrí set off to take the inaugural photographs for this book.

The Dominican College stands on a hill just outside Wicklow town, hidden from the road by high walls. The beautiful entrance gate photographed by Father Browne in 1933 is nowhere to be seen (page 48). At the entrance are signs for an organic farm shop and an ecology centre. Where exactly was the convent?

Following in the footsteps of Father Browne not only took us back in time but required us to do that most archaic of things: ask for directions. Old-school methods of finding our way became something of a feature of this journey.

Passing the front door of the convent, we ascended a steep path along the right-hand side of the building, past deserted basketball courts, and along a high path to the spot where Father Browne took his photograph of the 'Convent and new boys' school' in 1944 (page 51). As we went about finding the right angles and composition, I felt strangely nervous about presuming to copy such a well-respected photographer. I moved the tripod this way and that in the knowledge that all those years ago Father Browne had stood here doing the same thing.

We only had to move three or four feet to take the next photograph – of 'Wicklow town and seafront' (page 53). Taken in 1942, two years before the convent image, it is obvious Father Browne was familiar with this vantage point and used it well. This photograph has a clever composition: by making the image two-thirds sky, the busy foreground is minimised, and the

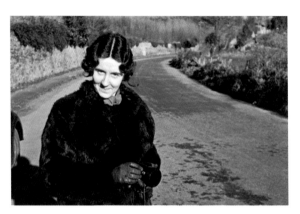

1939: *'Two Steps' Miss Nolan of Dominican Convent Wicklow. Not alone with a camera on this day, Father Browne seemed to have enjoyed the company of other photographers. We can but speculate on the nickname 'Two Steps'*

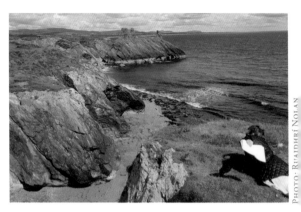

2020: *Miss Nolan, myself, a graduate of Dominican Convent Cabra, in rather ungainly prostration to see if this angle will capture Wicklow Castle. The sheet of paper in my hand is a copy of Father Browne's photograph of the castle ruins*

eye is trained to the stone arch bridge in the distance on the left, which itself draws a line to the sandbar stretching from the centre of the image in a pleasing arc to the right.

The question can be asked: was Father Browne a documentary photographer or an artist-photographer? Of course, he was both. In these first two shots, we have an example of each. The photograph of the school documents the new building and was a nice gift to give to the convent for their archives. The photograph of the town and seafront has the composition of a master painter. Father Browne photographed as both documenter and artist, and the 42,000 negatives he left behind prove that these two roles are not mutually exclusive.

He was also, at times, a mountain goat: the photograph of the Wicklow Lighthouse (page 64) is proof of that. It was no mean feat to reach the point where he took this shot, and had we moved any further to our right we would have fallen off the cliff into the wild sea below. As the wind howled in a disconcerting swirl, I considered that allowing for erosion, I was perhaps closer to death than had been the man himself, but I fear the photograph belies this. Taken 86 years apart, the rock formations remain identical, and if there has been any erosion, it is minimal.

The act of putting my eye over the eye of this great photographer increased awareness of his technique, which I believe through constant use became a natural

working part of his mind. Whenever Father Browne took a photograph straight on, not from above or below, it was only because he knew this offered the finest result. I suspect his clothes got dirty often as he lay on damp ground to add a few more degrees to the angle of a shot, and have little doubt he risked limb, if not life, to gain extra height and drama. He lived at an exciting time for photography, starting with the nitrate film Kodak box camera he received as a gift aged 17, to the surprisingly compact Kodak Vest Pocket Camera taken aboard the *Titanic*, to various 35mm cameras as they became available, including the Zeiss Contax I and II, a Super Nettel and a Leica.

Bear in mind also that he had been badly injured in the First World War, a fact not evident in the physicality of some of his post-war photography escapades. Between the restrictions of camera technology and his own health, I was in awe following in his footsteps with my digital camera, and with no such war wounds of my own.

Perhaps the most unusual location we visited was Shelton Abbey (page 90), now an open prison. Once a private estate, it hasn't suffered for the dramatic change of use, with the impact of its grandeur intact and the beautifully kept house and grounds a credit to all who reside therein. If pictures tell a story, then Shelton Abbey is an example of how they don't always tell the whole of it. When Father Browne took his photograph in 1946, the splendour he captured

belied that within five years, the then-owner's financial difficulties meant he would sell the abbey and grounds to the Irish state. Likewise now, as an open prison, the grand but impassive exterior gives nothing away about the life of the occupants behind the many windows. Finding the abbey was tricky, and involved some ordnance surveying of a terrain map of the area. It isn't highlighted by satnav or signage until you are almost upon it. It is not, however, open to the public and we were granted permission to visit the exterior only, on the basis that we were taking photographs for this book.

However, linear time and the deadline for this book marched on, and so to our next stop, Powerscourt Waterfall (page 106). Please do not use technology to find Powerscourt Waterfall, or you will get lost. Go old-school and look for signposts or ask for directions. At the waterfall, Father Browne took a photograph of a man sitting with his back to us, and so we set about doing the same. But the landscape close to the waterfall has changed utterly, and where a tree trunk once sat in 1933, now is all rock. Slippery rock! To get our stand-in onto a suitable but safe rock, and into the correct position, was hair-raising, and I don't recommend anyone tries to do this. The stand-in as it happens was my assistant Ruaidhrí, who is my son, so there was considerable inner conflict between the mother and the photographer who wanted the shot! I wondered had Father Browne the priest had the same conflict with Father Browne the photographer, and if his subject, in contemplating the waterfall, was also dreading the slippery clamber back to dry land.

The next shot was the nearby Dargle Glen (page 110), where we endeavoured to recreate the oldest photograph in the book. Father Browne's beautiful, mystical idyll was taken 110 years ago. It is quite a stretch to claim we took this in the same spot, but we tried. Trees have grown and fallen, rocks have shattered and collapsed into the water; it's impossible to know after over a century of natural change. But the rock formation behind the figure in the 2020 photograph has a similar semi-circular shape to the tall formation in the 1910 photograph, and the sapling in the older shot could be the mature tree in the newer one.

In order to replicate Father Browne's 1926 photograph, 'Deserted Promenade, Bray' (page 23), I travelled to Bray very early one Saturday morning. I was correct in thinking most people would be tucked up in bed at that hour, but Father Browne's photograph included a family walking towards him. What to do? I stood on the deserted promenade with the printout of Father Browne's photograph in one hand and the camera in the other, all around me bereft of human life. Then, serendipitously, I spotted a family walking across the grass from the road to the prom. I asked if I could take their photo for this book, and was delighted when they agreed. The only instruction I gave them was to walk towards me on the prom. As they did, I took multiple shots.

It is uncanny how the postures of two of the children are the same in both promenade photographs. The names of the children in the 2020 photograph are Matilda and Mabel. One could walk a long way to find children today with names more suited to Father Browne's time. It is as if he was there in this double-exposure across a century.

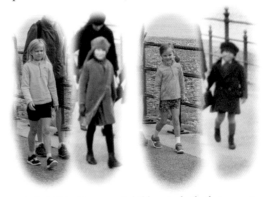

2020 & 1926: *Postures of children in both photos compared*

Bray and its hinterland can be considered as an introduction to Wicklow, as many of the county's essential characteristics can be found here, not least in the alignment of water and mountain, with the Irish Sea on one side and the lower slopes of the Sugarloaf mountain on the other. Some 20 kilometres south of Dublin, Bray was a small coastal town until the middle of the nineteenth century when linked by rail to the capital. As a consequence of this development, Bray became easily accessible to Dubliners who for the next 100 years flocked there to enjoy bathing and other seaside amusements. While some of the town's Victorian delights, like the Turkish Baths, have gone, others remain, not least the mile-long promenade, created by railway magnate William Dargan and completed in 1859.

For this enterprise, Dargan had to lease the ground running parallel to the shore from William Brabazon, Earl of Meath. The Brabazons had come to this part of the country in the sixteenth century, acquiring an estate called Killruddery, which remains their home. Set within a seventeenth-century parkland, the present house is smaller than was the case when seen by Father Browne: rampant dry rot meant large parts of the building had to be demolished in the 1950s.

Originally Killruddery would have been surrounded for many miles by open countryside, interspersed with small urban settlements to the south like Greystones on the coast and Delgany a little further inland. However, over the past half century much of this part of the county has been developed for housing, so that at least some of its pastoral character has been impaired. However, to the immediate west lies the Glen of the Downs, a wooded glacial valley admired for its outstanding natural beauty since the eighteenth century.

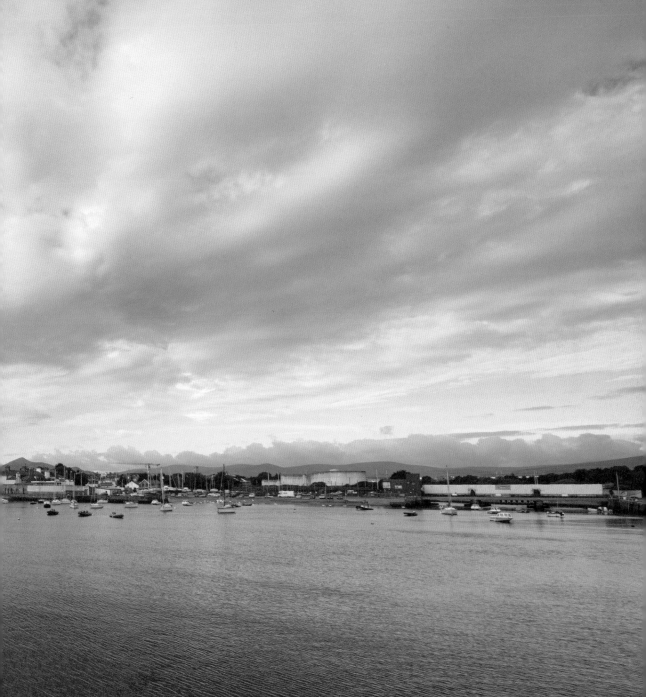

BRAY

*Bray, Kilcroney, Killruddery, Glen of the Downs,
Greystones, Delgany, Kilcoole*

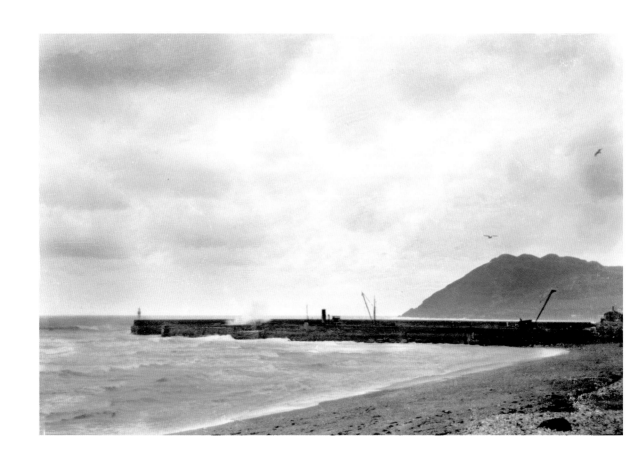

1938

Bray Harbour and Bray Head

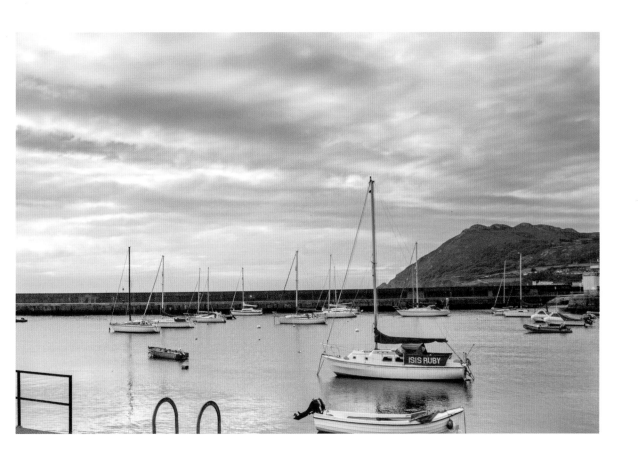

2020

Bray Harbour and Bray Head

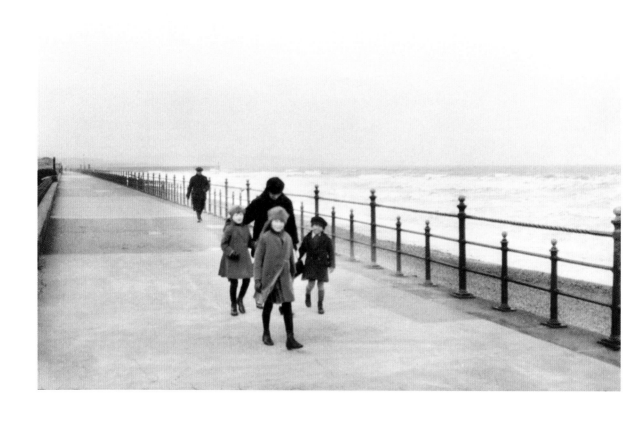

1926

Deserted Promenade, Bray

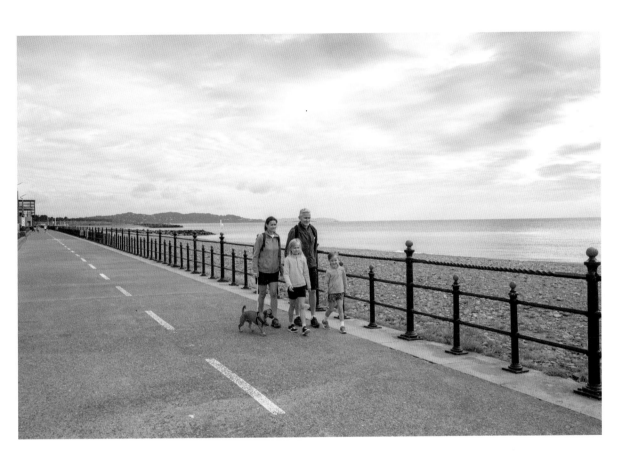

2020

Deserted Promenade, Bray

Sarah & Philip Byrne taking an early morning walk with their dog and their children, Matilda & Mabel

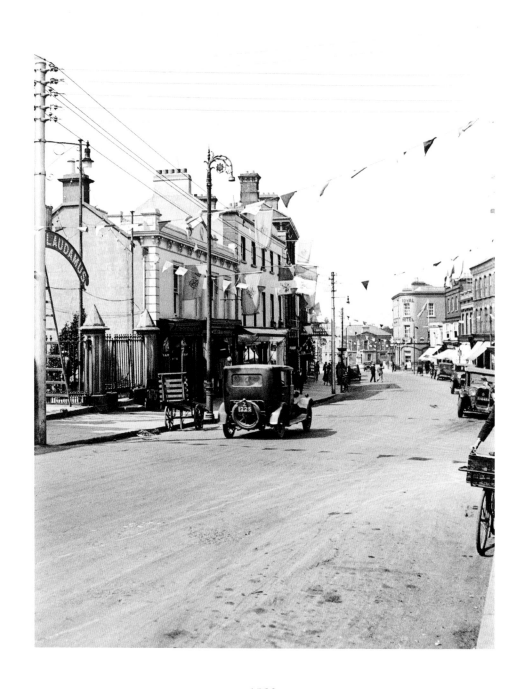

1932

Preparations for the 31st Eucharistic Congress, Bray Road, Bray

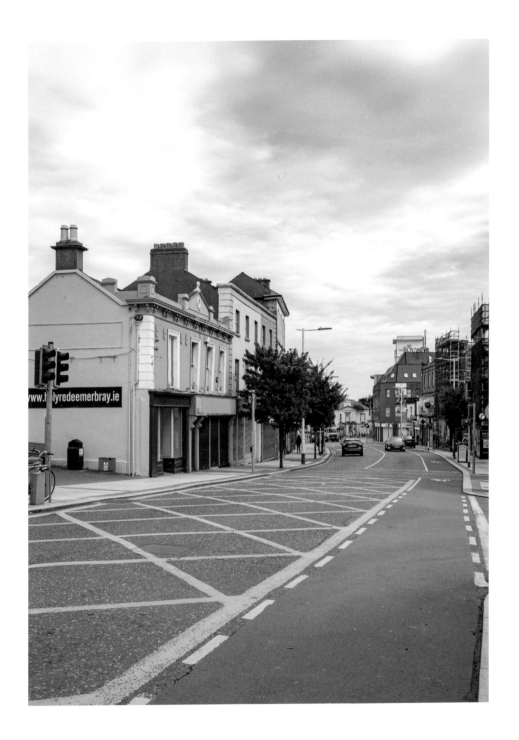

2020

Bray Road, Bray

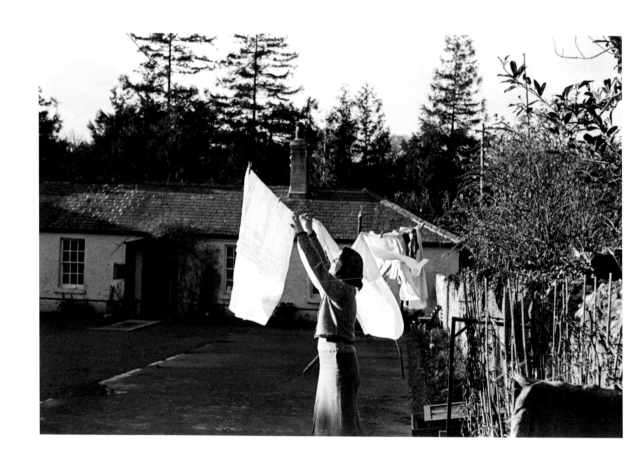

1942

Hanging out washing at St Ciaran's College, Bray

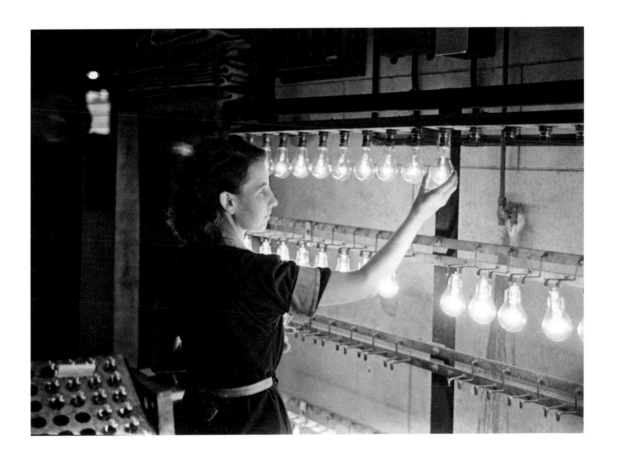

1942

Solus Teoranta Lightbulb Factory, Bray

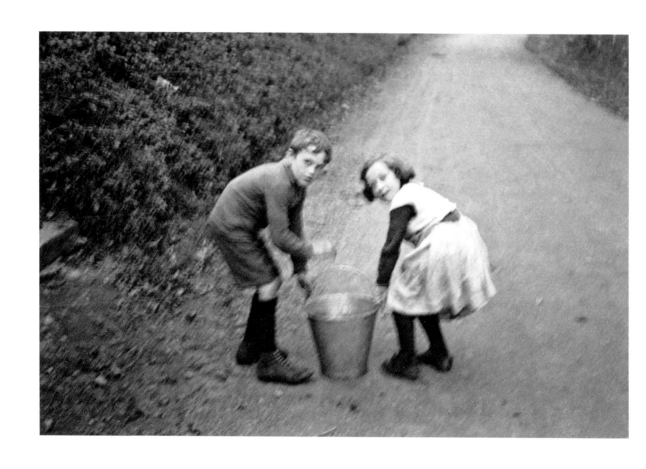

1937

Children, Bray

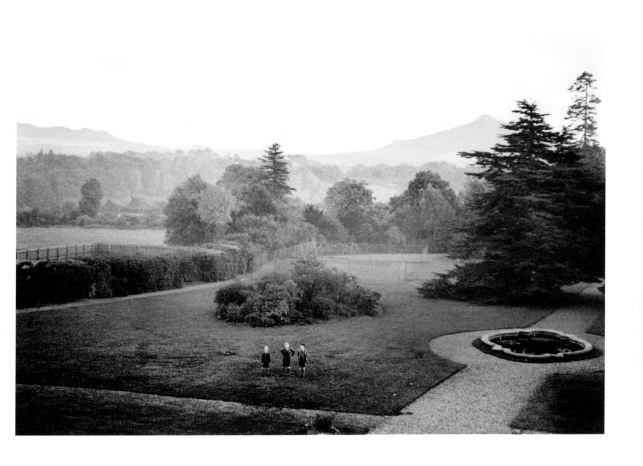

1937

St Gerard's School, Bray

1937

St Gerard's School, Bray

1937

St Gerard's School, Bray

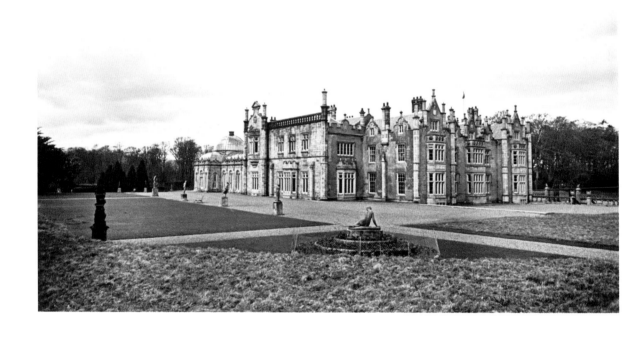

1947

Killruddery House taken from the south-east exterior

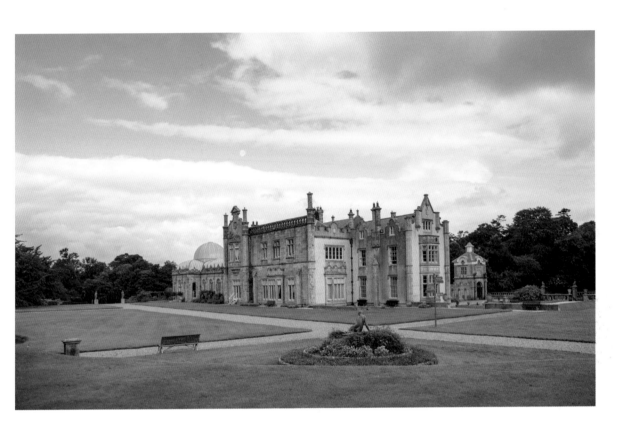

2020

Killruddery House taken from the south-east exterior

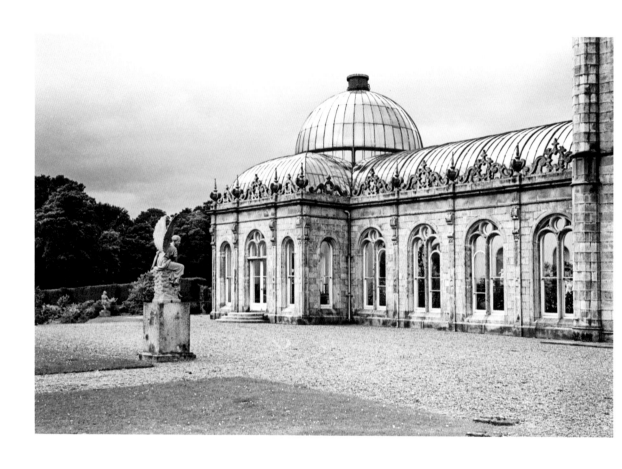

1947

Killruddery House Sculpture Gallery exterior

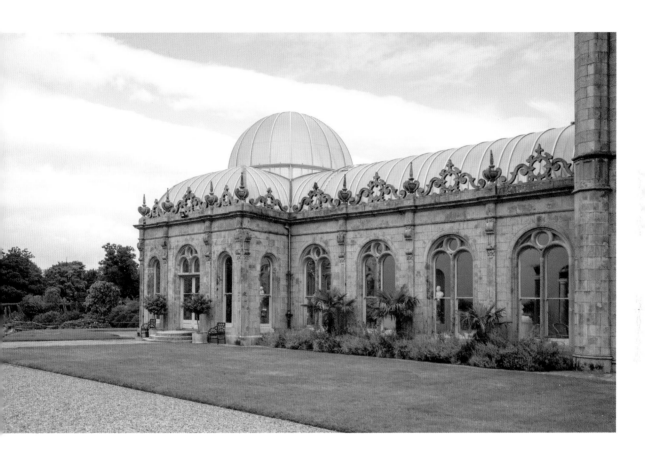

Killruddery House Sculpture Gallery exterior

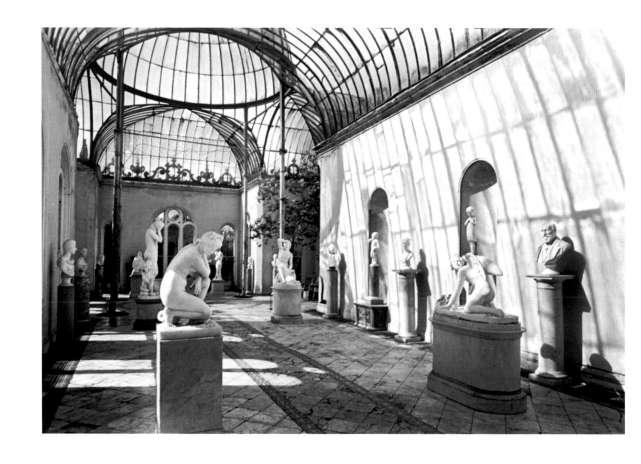

1947

In the Sculpture Gallery, Killruddery House

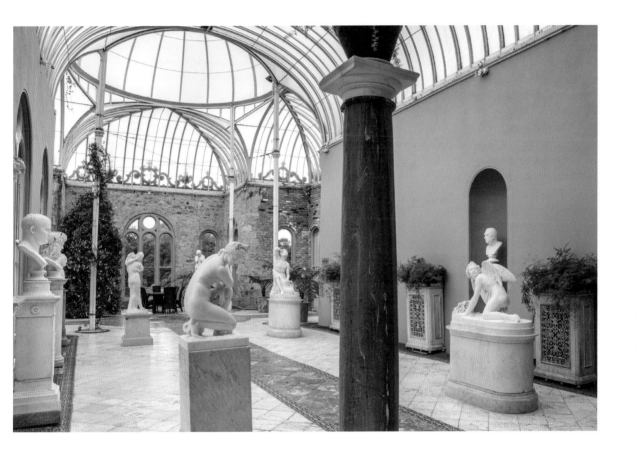

2020

In the Sculpture Gallery, Killruddery House

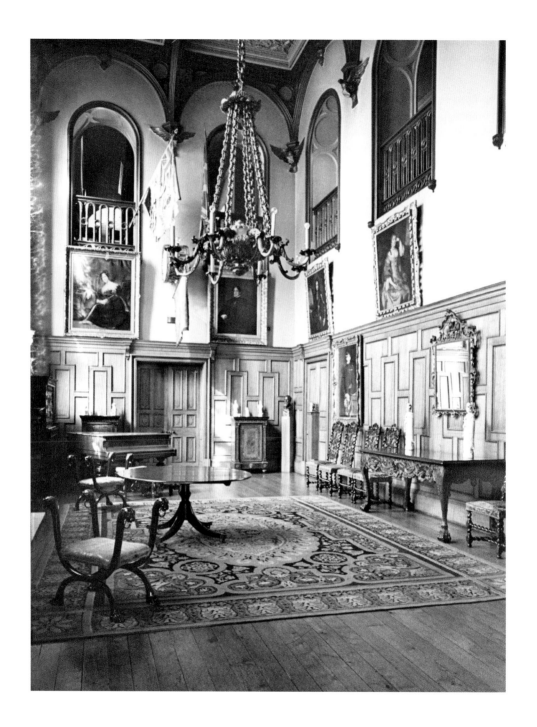

1947

The Great Hall, Killruddery House

1933

Panorama with lady, Kilcroney

1930

Chestnuts in bloom, Kilcroney

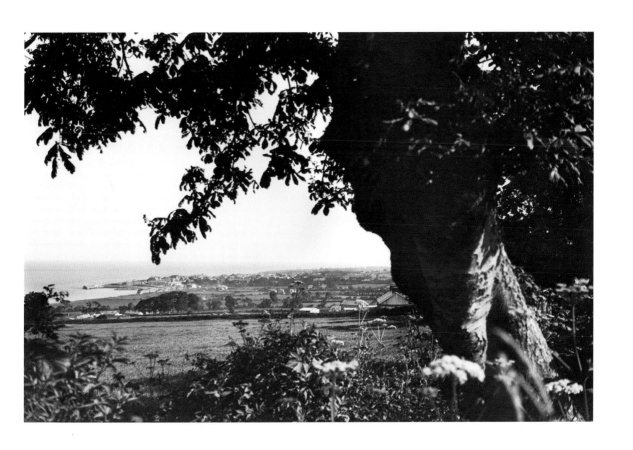

1925

Greystones from Windgates Road

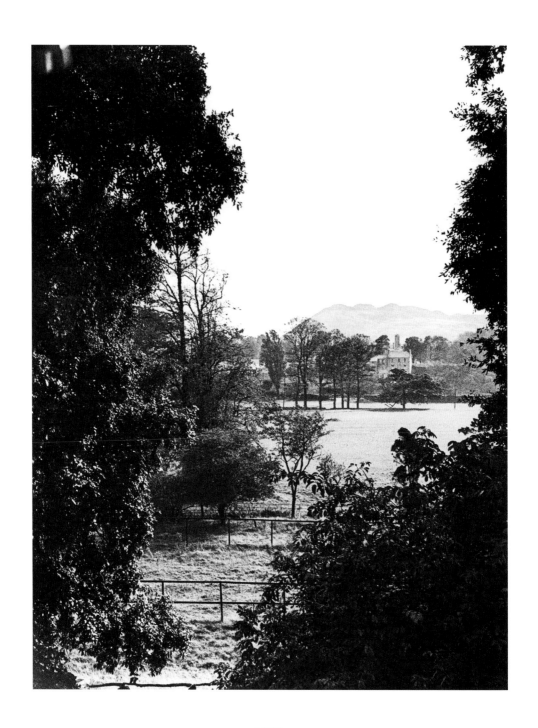

1933

House and Bray Head

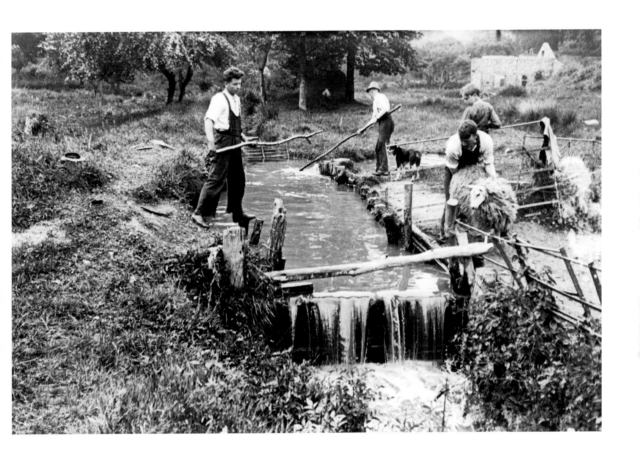

1932

Sheep dipping, Glen of the Downs

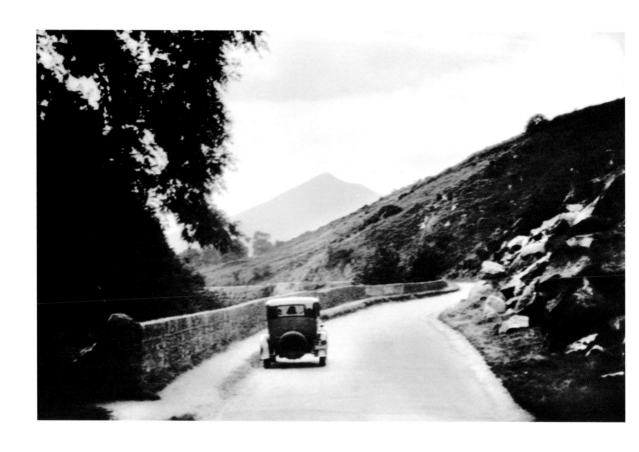

1929

Sugarloaf mountain from Scalp

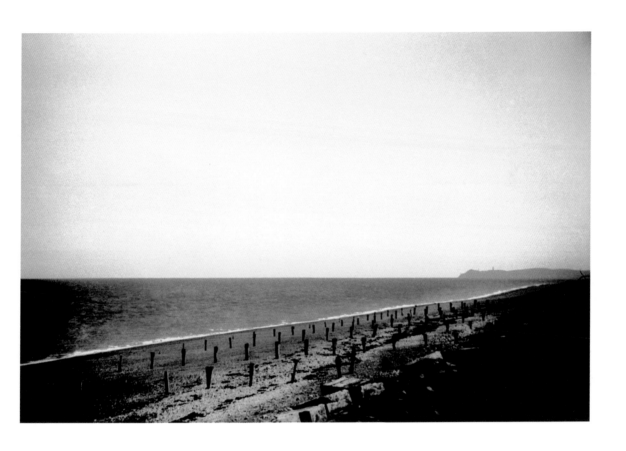

1930

Foreshore with surge breaking posts near Kilcoole

The charming villages of Ashford and Rathnew both lie to the south of Bray, but neither is far from the coast. For hundreds of years, they were places where travellers could change their horses and find rest and refreshment at an inn: in Samuel Lewis's *Topographical Dictionary of Ireland*, published in 1837, the author wrote that Rathnew's inn 'has long been celebrated for the beauty of its situation and the excellence of its arrangements.' Not far away stood several fine estates, not least Rosanna, home to the Tighe family, and Clonmannon.

A few kilometres away, the county town of Wicklow owes its development to a natural harbour that attracted Viking settlers in the ninth century: it has been proposed that the place's name comes from the old Old Norse word *Víkingaló*, meaning 'Meadow of the Vikings'. In due course, they were followed by the next invaders, the Anglo-Normans who arrived in Ireland in the twelfth century. This part of the country then came under the control of Maurice FitzGerald, responsible for commissioning the Black Castle, the ruins of which can be seen to the immediate south of Wicklow town. The port here has long been a centre for fishing, as well as other commercial maritime industries and, allowing for more recent interventions, still retains much of the character captured by Father Browne.

So too does the town, which largely dates from the late eighteenth and nineteenth centuries. Wicklow was among the major centres of anti-government activity during the 1798 Rebellion, as is evidenced by a statue in the centre of the Market Square. Unveiled in 1900, this commemorates William Byrne, a local leader who was captured by crown forces, convicted of treason and executed.

WICKLOW

Ashford, Rathnew, Wicklow, Glenealy

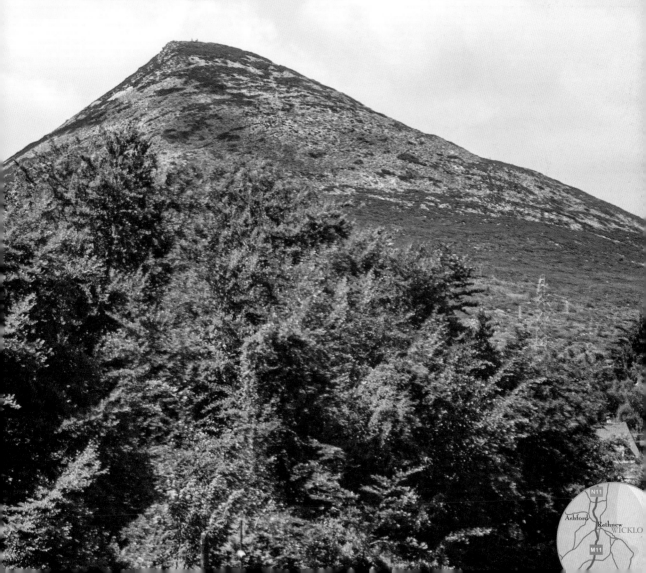

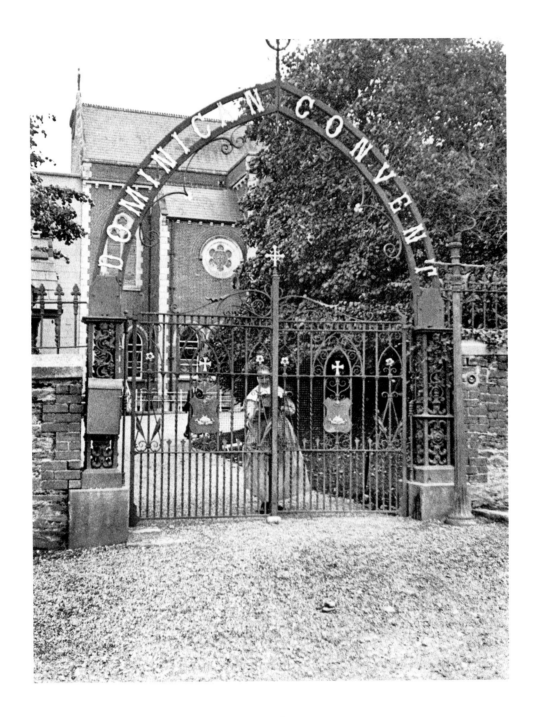

1933

Dominican Convent gate, Wicklow town

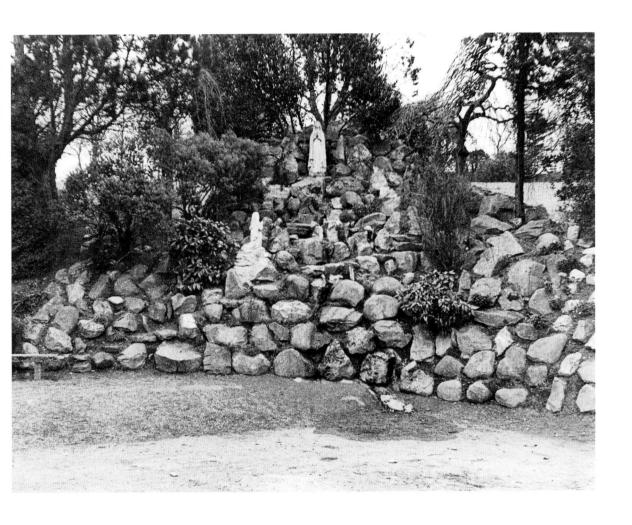

1934

Dominican Convent Lourdes Grotto by day, Wicklow town

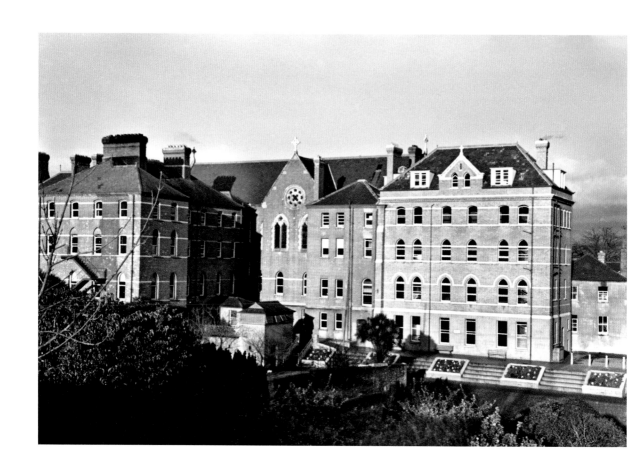

1944

Dominican Convent with new boys' school

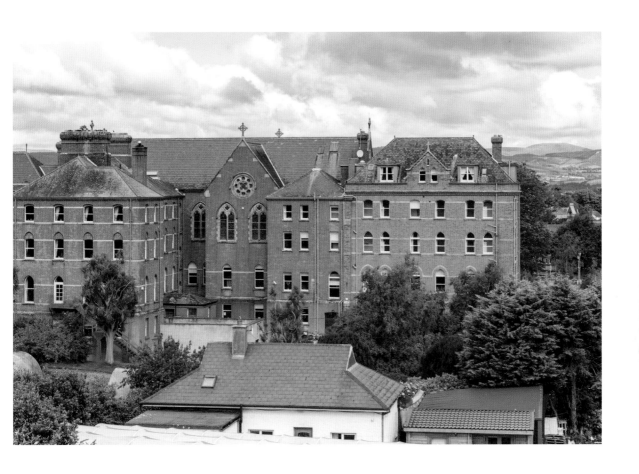

2020

Dominican Convent and school

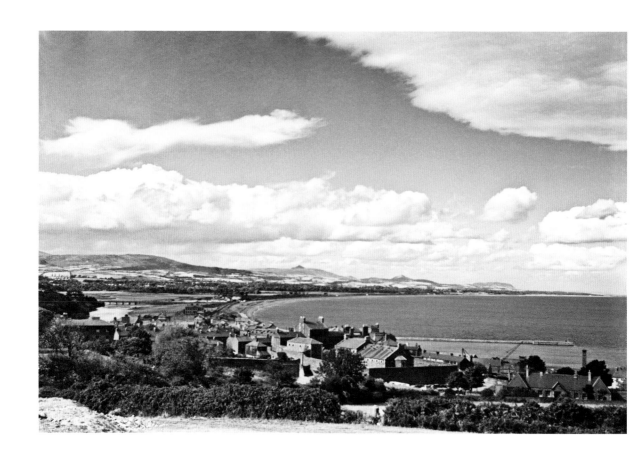

1942

View of Wicklow town & seafront from the hill behind Dominican Convent

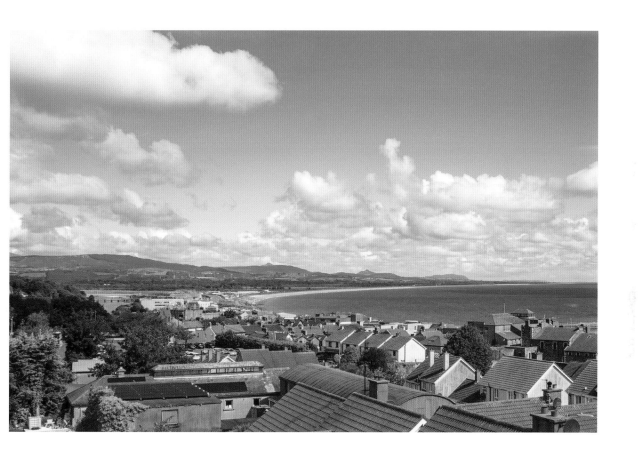

2020

View of Wicklow town & seafront from the hill behind Dominican Convent

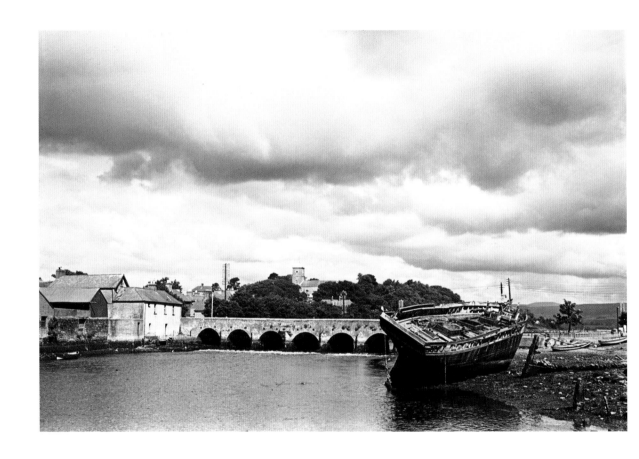

1944

River Vartry and bridge, Wicklow town

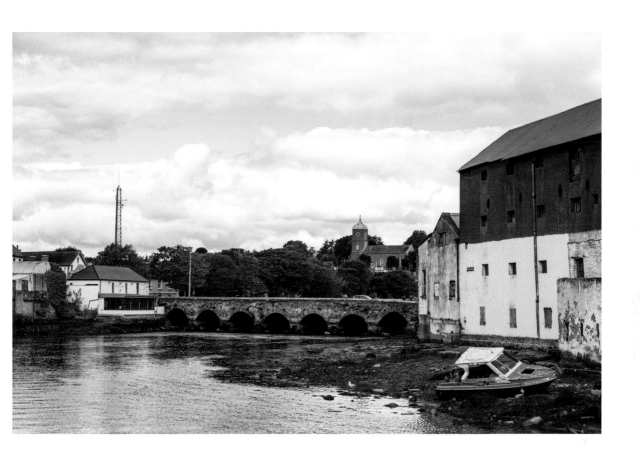

2020

River Vartry and bridge, Wicklow town

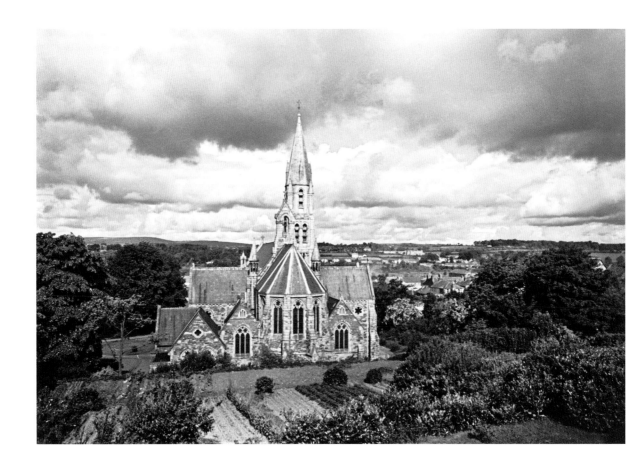

1939

Parish Church

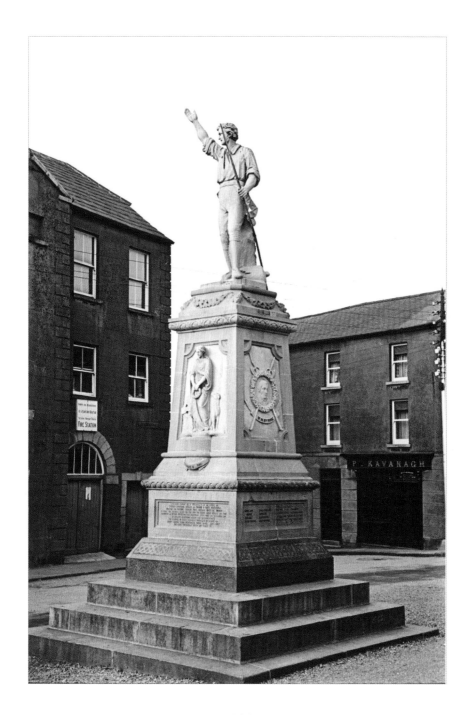

The Byrne Monument of a 1798 pikeman, Wicklow town

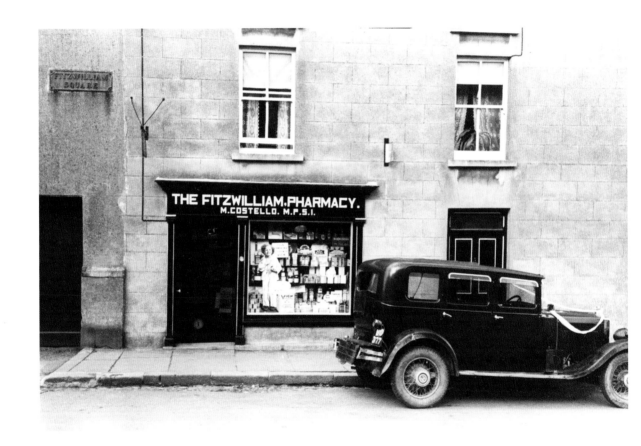

1938

Fitzwilliam Square, Wicklow town

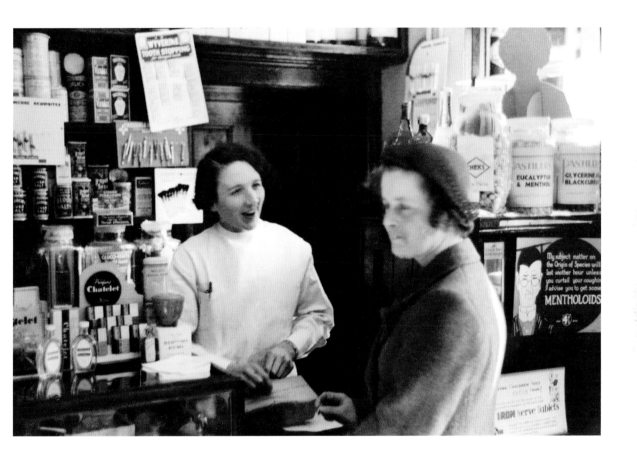

1938

Miss Costello serving in Fitzwilliam Pharmacy, Wicklow town

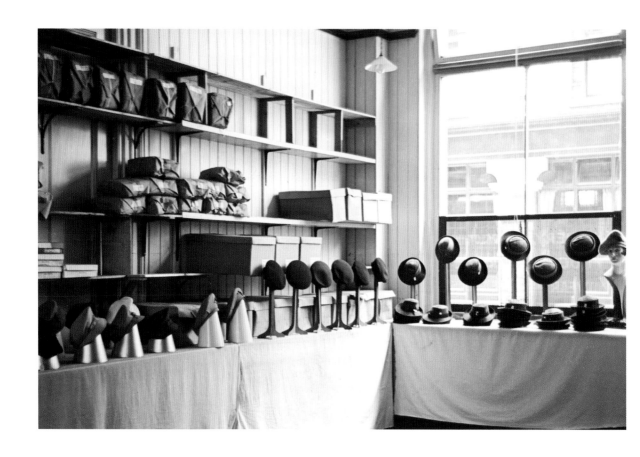

1944

The Hat Shop, Wicklow town

1949

Ado Carton, Chairman of Eggsporters Ltd, Wicklow town

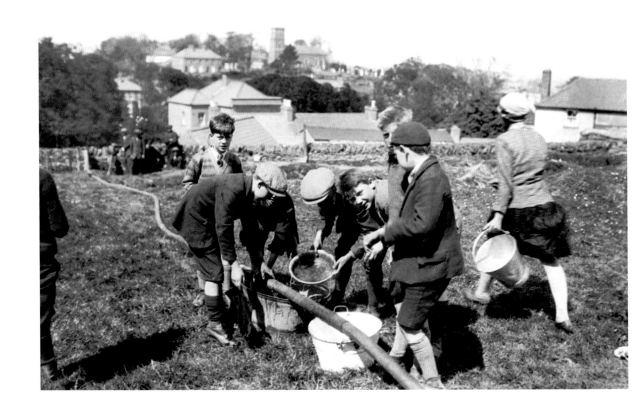

1928

Boys filling buckets from the leaking hose, with the presbytery on fire

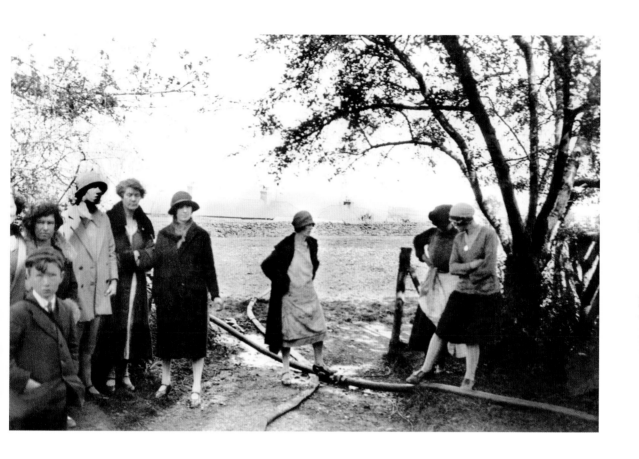

1928

Ladies using their feet to stop holes in the hose, the better to fight the presbytery fire

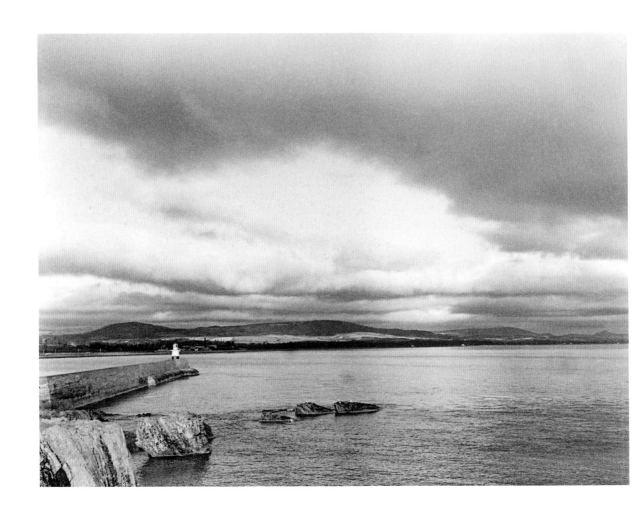

1934

The Lighthouse, Wicklow town

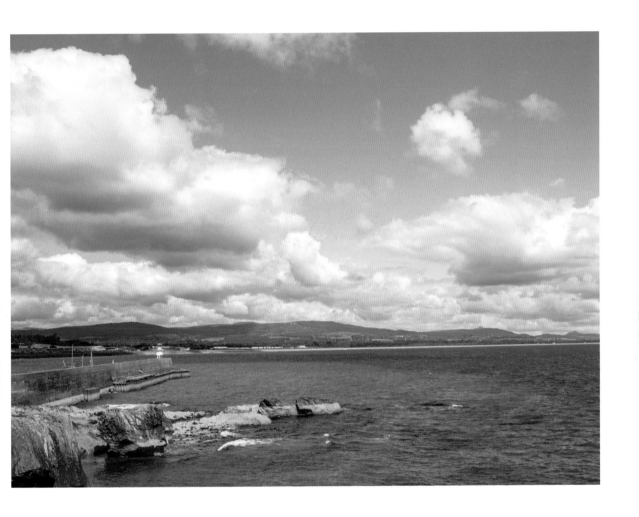

2020

The Lighthouse, Wicklow town

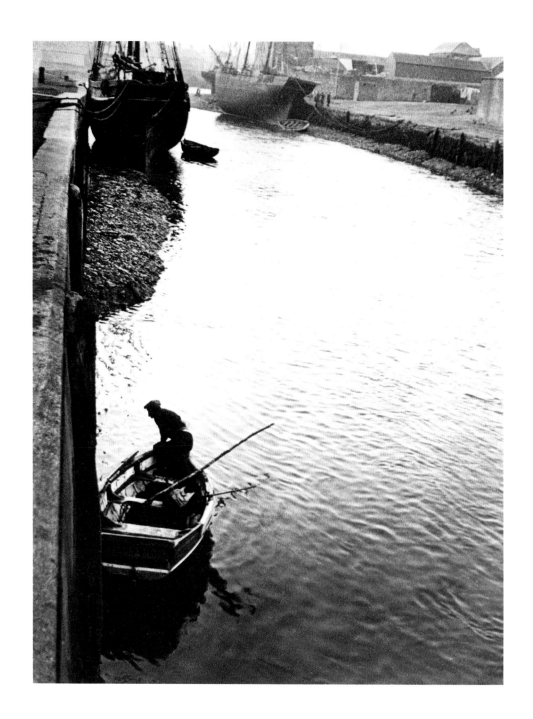

1934

Wicklow Harbour scene

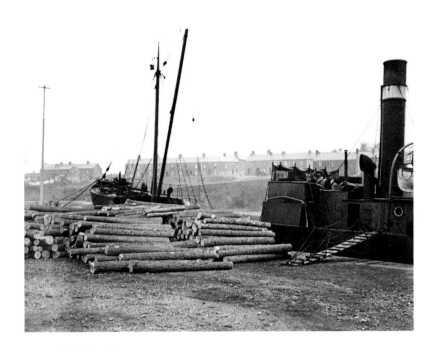

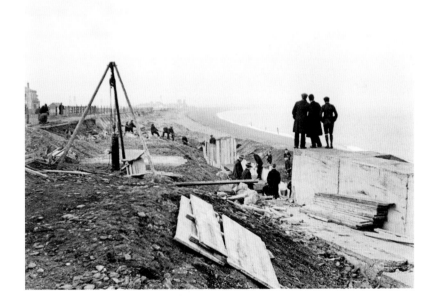

1934 1934

Wicklow Harbour *Broken sea wall, Wicklow town*

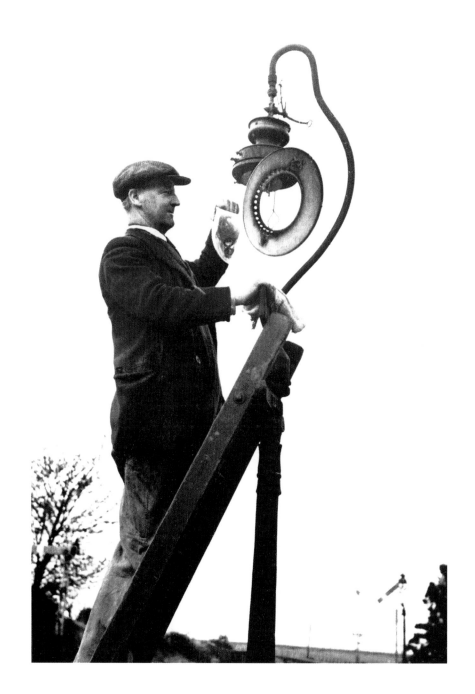

1939

Repairing lamp, Wicklow town

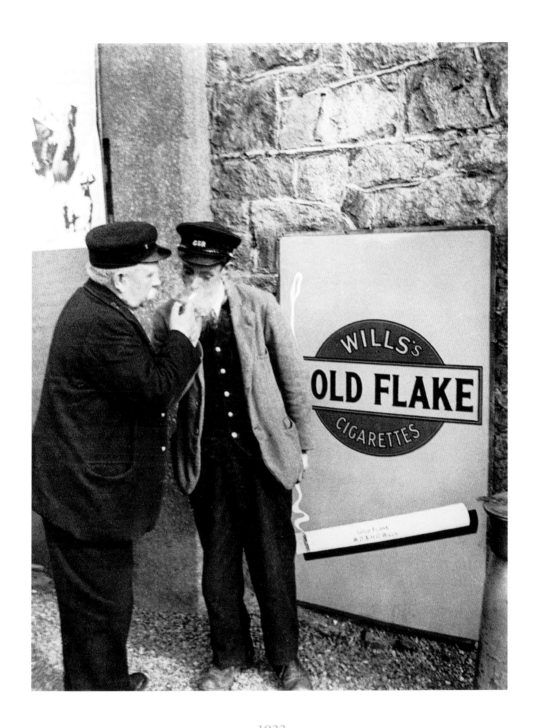

1933

Great Southern Railway (GSR) officials at railway station & advertisement for Gold Flake cigarettes

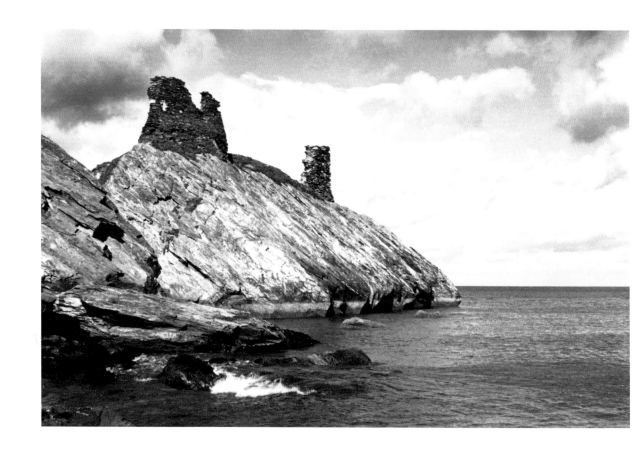

1939

Wicklow Castle

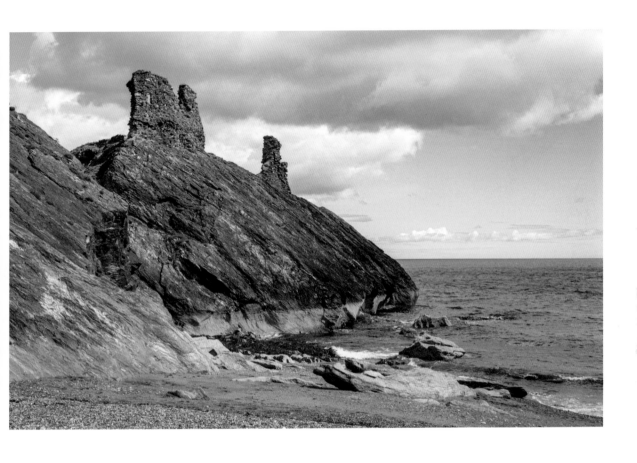

2020

Wicklow Castle

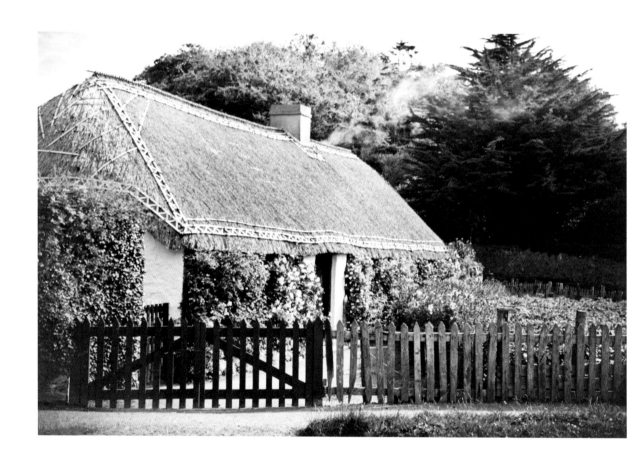

1942

Cottage exterior, Rathnew

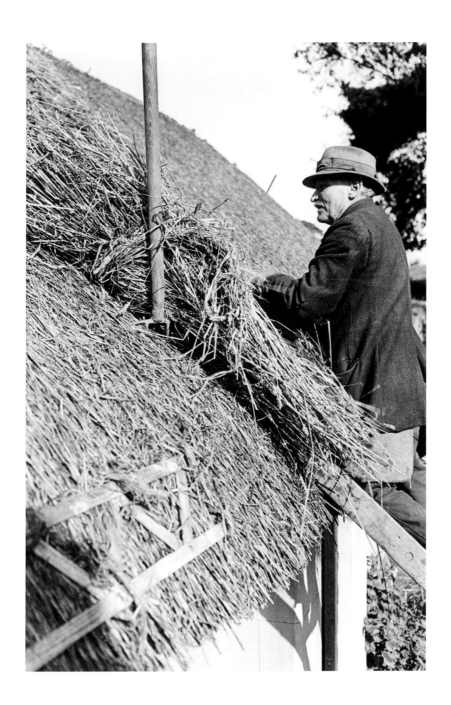

1932

The thatcher, Ashford

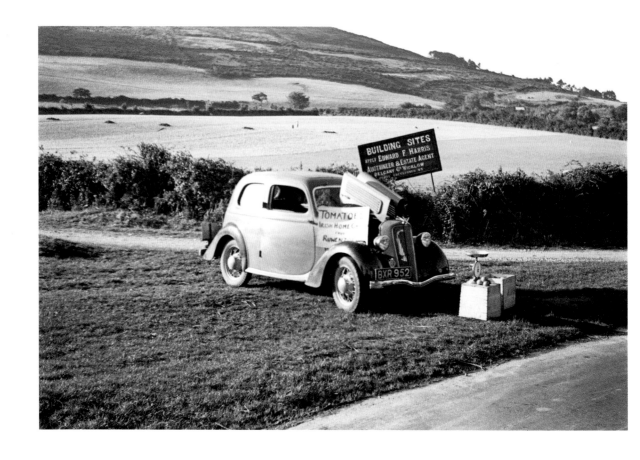

1937

Selling tomatoes on a Wicklow road

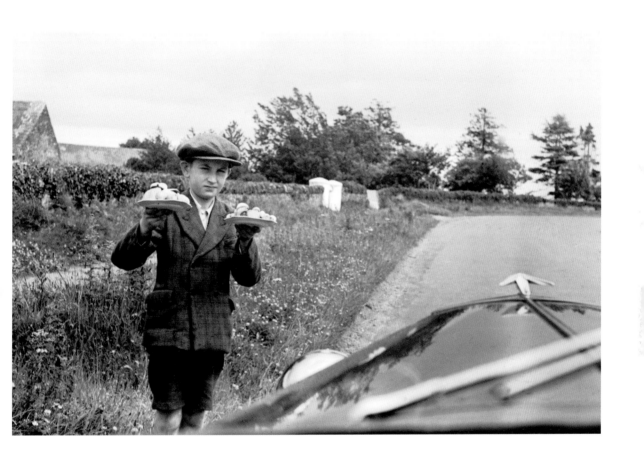

1942

Mushrooms sold

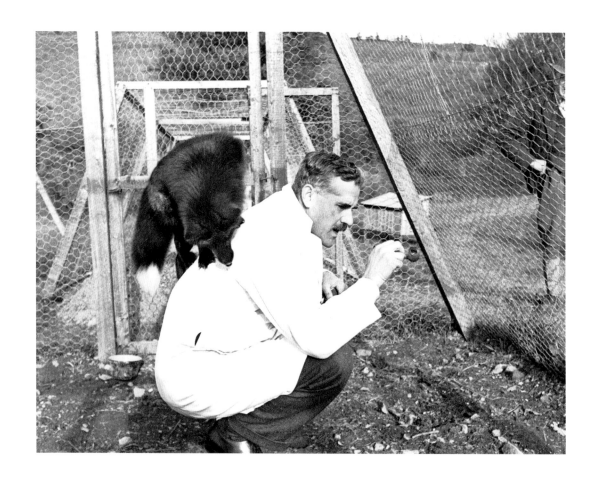

1933

Mr O'Driscoll's Silver Fox Farm, Ballyfree

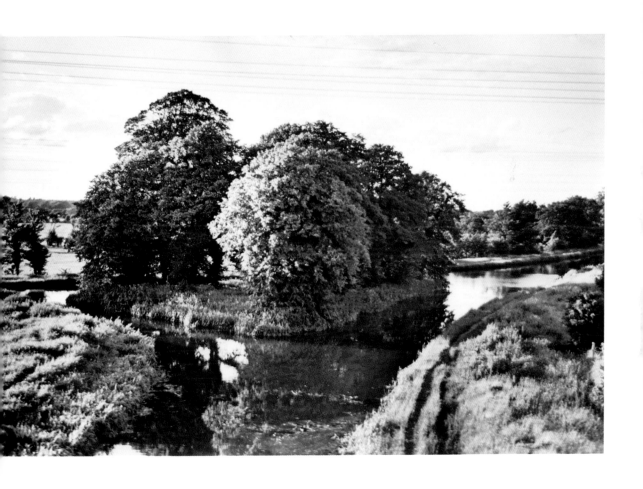

1941

River view in the Wicklow countryside

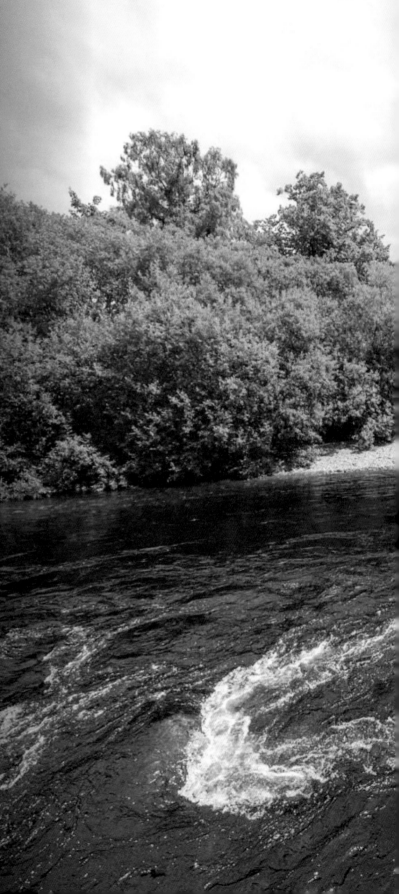

Like Wicklow some 25 kilometres north, Arklow owes its origins to the Vikings who recognised the advantages of its natural port at the mouth of the Avoca, the longest river in the county. Again, like Wicklow, Arklow was a centre of activity during the 1798 Rebellion: a battle took place here on 9 June when a large force of United Irishmen from Wexford were defeated by British troops. A statue of Father Michael Murphy, who was killed in the course of the battle, stands in the centre of the town. Father Browne's photographs of Arklow, taken during a visit in 1942, show how busy the port remained during the years of the Second World War, known in Ireland as the Emergency. At that time there were few cars in the country, so trains were an important – and in-demand – means of transport for those who needed to travel to Dublin or other centres. But Arklow was itself expanding at this time as can be seen by Father Browne's photographs of the successful boarding school run by the Sisters of Mercy in the town.

As mentioned, Arklow stands at the point where the River Avoca enters the Irish Sea. Further upstream it passes through the pretty village of Avoca, celebrated in Thomas Moore's poem 'The Meeting of the Waters' (1807). The river also originally flowed through the grounds of Shelton Abbey, long-time seat of the Howards, Earls of Wicklow. Originally a classical mansion, it was transformed into a fantastical Gothic castle at the start of the nineteenth century by architect Sir Richard Morrison. In the 1940s, soon after Father Browne's visit to the estate, the eighth Earl of Wicklow opened the abbey as a country house hotel but the venture was not a commercial success. Today Shelton Abbey is an open prison.

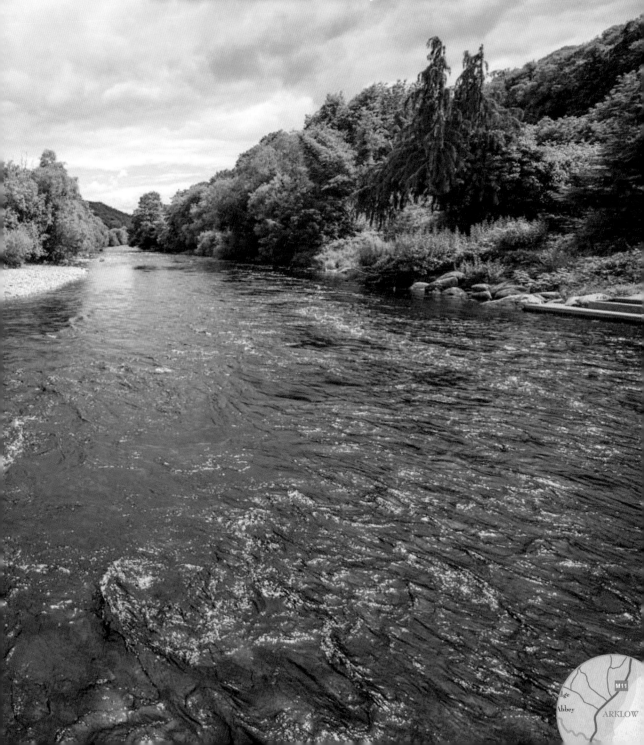

ARKLOW

Arklow, Shelton Abbey, Avoca

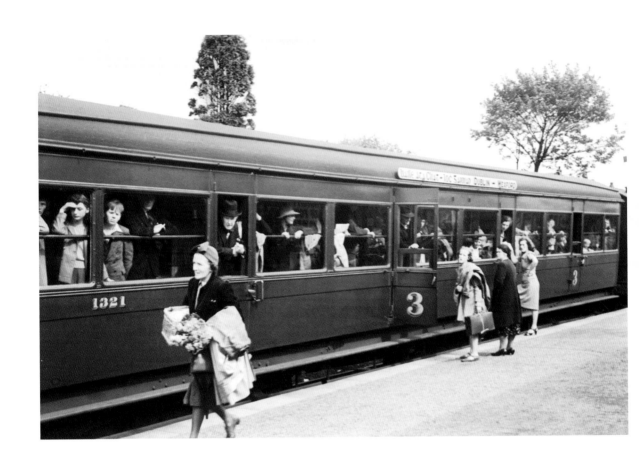

1942

Crowded train in wartime, Arklow train station

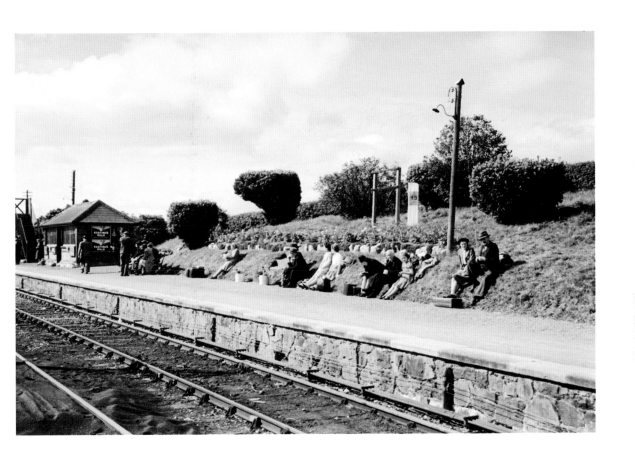

1942

Wartime waiting at Arklow train station

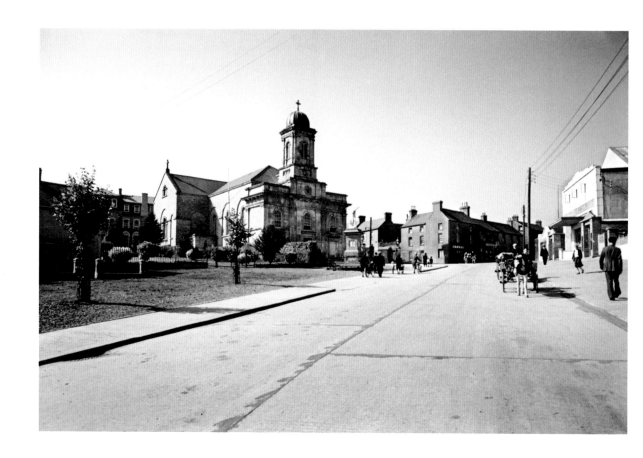

1942

St Mary's & St Peter's Catholic Church, Arklow, with statue of 1798 rebellion hero Father Michael Murphy

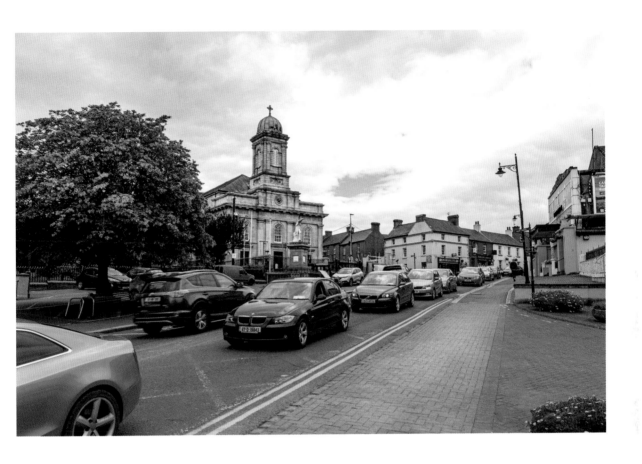

2020

St Mary's & St Peter's Catholic Church, Arklow, with statue of 1798 rebellion hero Father Michael Murphy

1942

Mercy Convent new school, Arklow

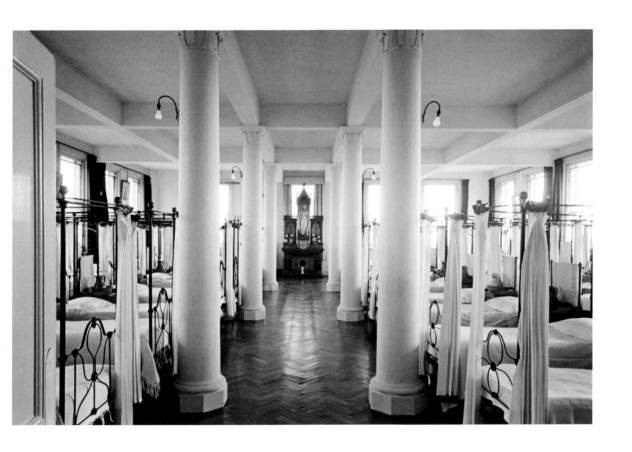

1942

Dormitory in Mercy Convent, Arklow

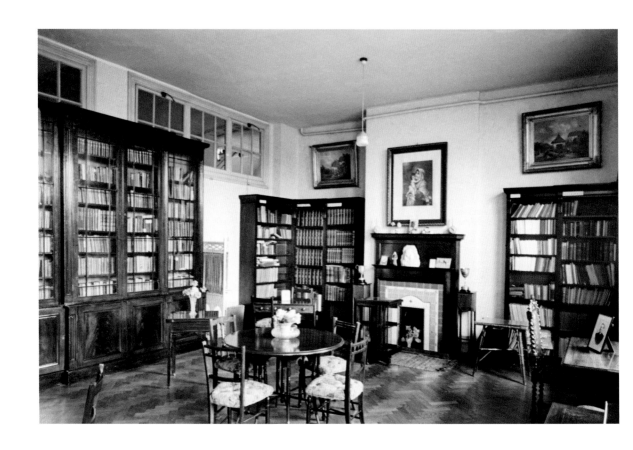

1942

Library in Mercy Convent, Arklow

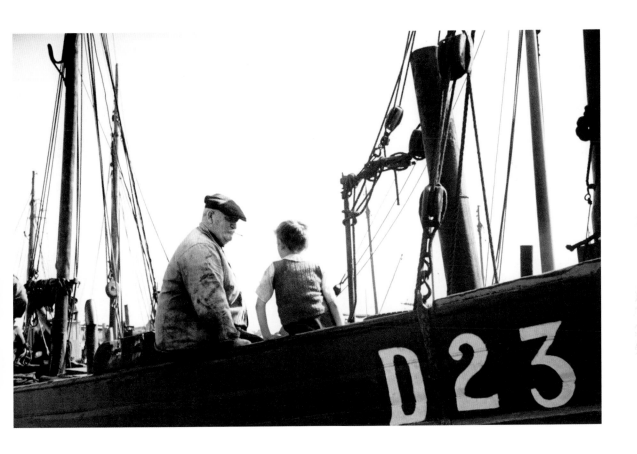

1942

Arklow Harbour scene

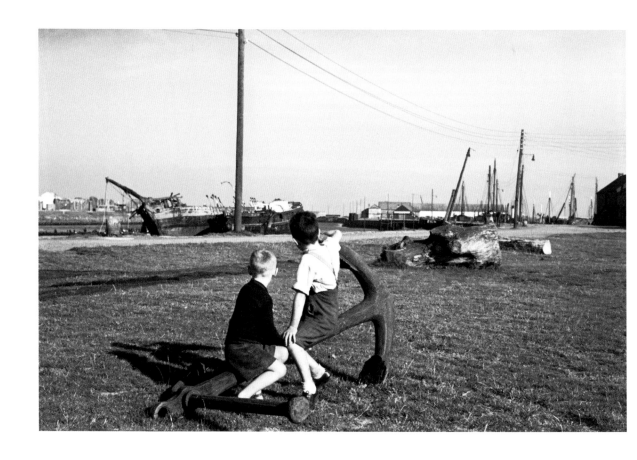

1942

Arklow Harbour scene with anchor

2020

Arklow Harbour scene with anchor

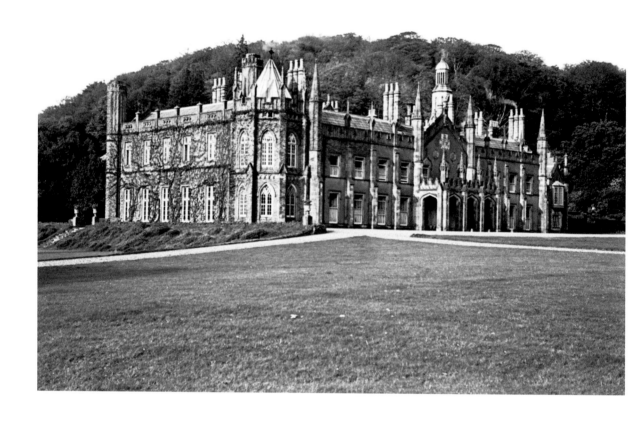

1946

Shelton Abbey from the south-east

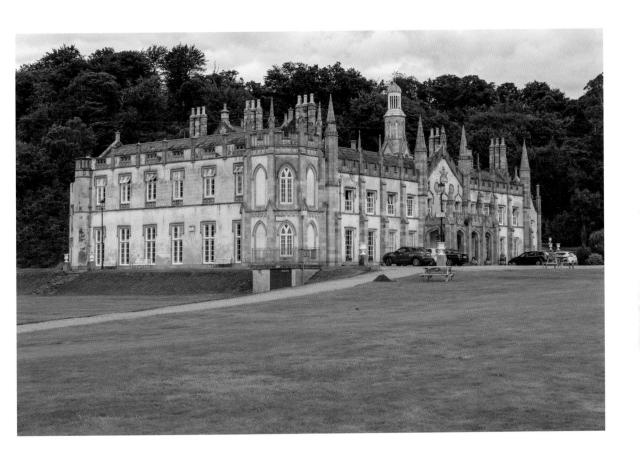

2020

Shelton Abbey from the south-east

1946

Shelton Abbey park from the terrace

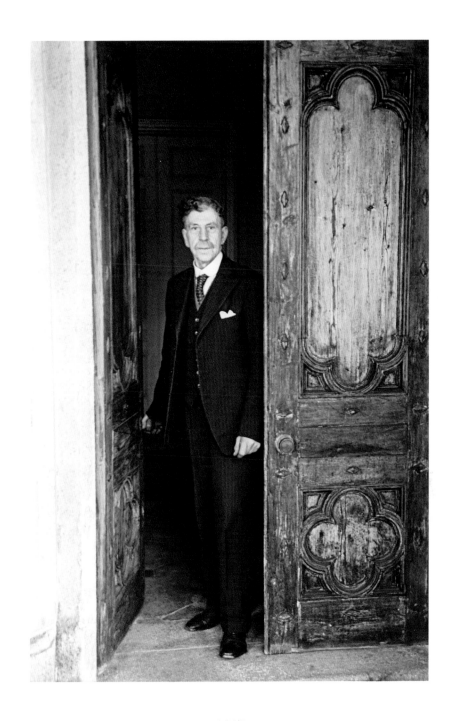

1947

Mr Virtue, butler, Shelton Abbey

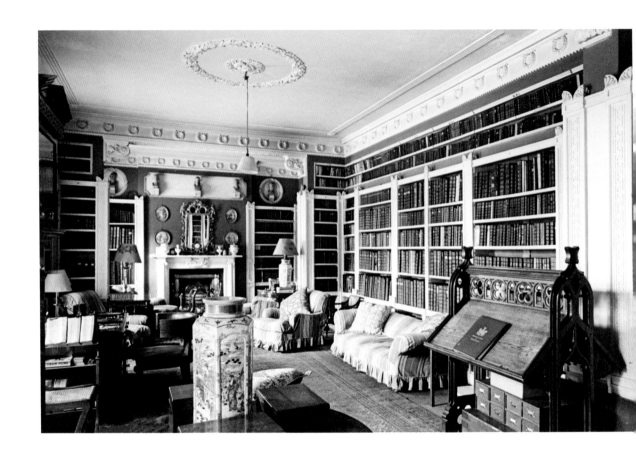

1946

The Library at Shelton Abbey

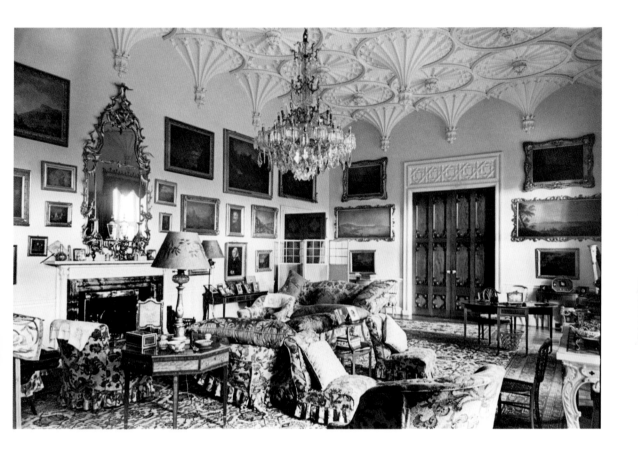

1946

Shelton Abbey saloon from south-west

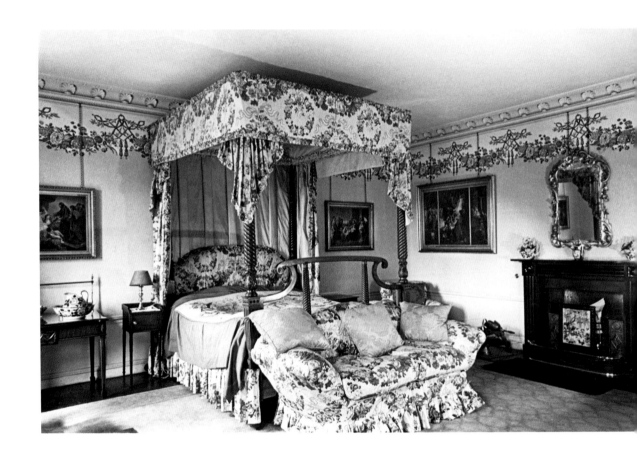

1946

Shelton Abbey Grand Bedroom

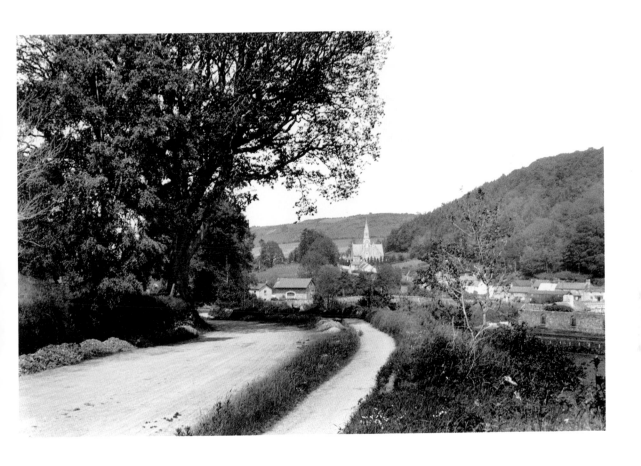

1925

On the road from Woodenbridge to Avoca

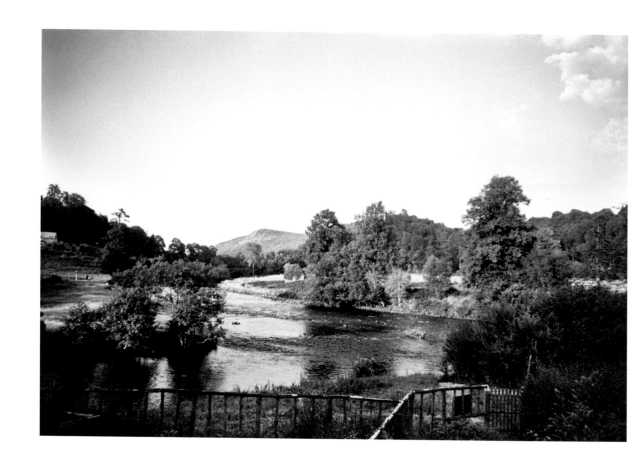

1942

Vale of Avoca

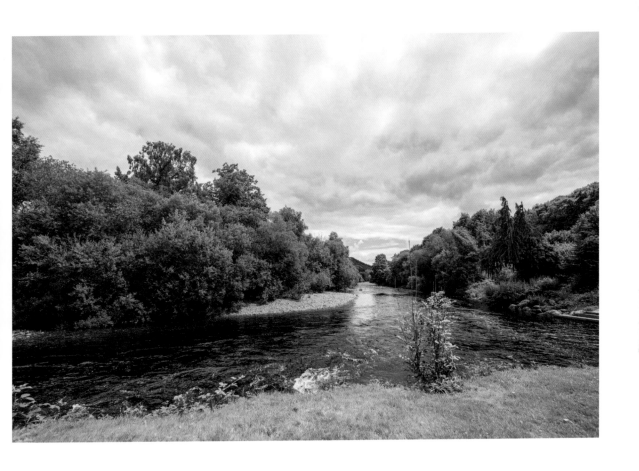

2020

Vale of Avoca

Like the Vale of Avoca, the Dargle Glen has long been renowned for its natural beauty, much admired by painters from the eighteenth century onwards. The River Dargle rises in the Wicklow Mountains and flows along peacefully until it plunges almost 400 feet at the Powerscourt Waterfall, the highest of its kind in Ireland. Famously in August 1821 the waterfall was damned in order to impress George IV, then on a visit to this country. Fortunately for him, the King stayed longer than expected at lunch because the water burst its damn and swept away the bridge on which he was supposed to stand.

George IV was being entertained nearby by Richard Wingfield, fifth Viscount Powerscourt on his estate of the same name. The house here, sadly gutted by fire in 1974, stands above spectacular terraced gardens created over a period of 20 years during the nineteenth century by the seventh Viscount, who imported statues and other ornaments from across Europe to improve the site.

The Wingfields were also responsible for the appearance of Enniskerry, the village which stands immediately outside the gates of their former estate. It was the fifth Viscount Powerscourt who at the start of the nineteenth century built, or rebuilt, many of Enniskerry's houses in the picturesque style which is still so much admired today.

Some ten kilometres to the immediate west and deep within the Wicklow Mountains lies the valley of Glencree, reached after passing through dramatic scenery. This part of the county was almost inaccessible until after the 1798 Rebellion when British authorities constructed a military road through the area. A barracks was built in Glencree and this later became a boys' reformatory school; today some of the site is occupied by the Glencree Centre for Peace and Reconciliation.

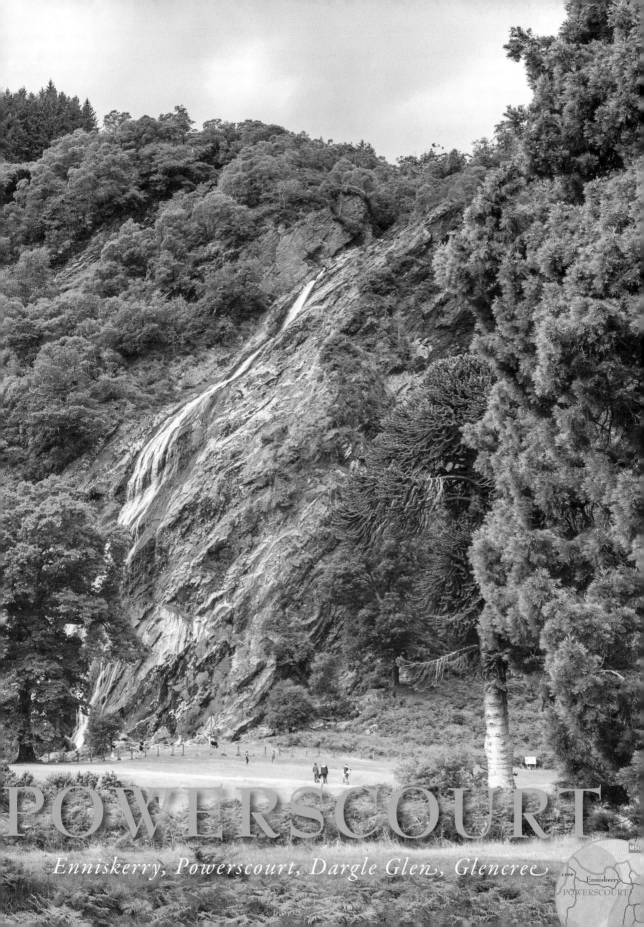

POWERSCOURT

Enniskerry, Powerscourt, Dargle Glen, Glencree

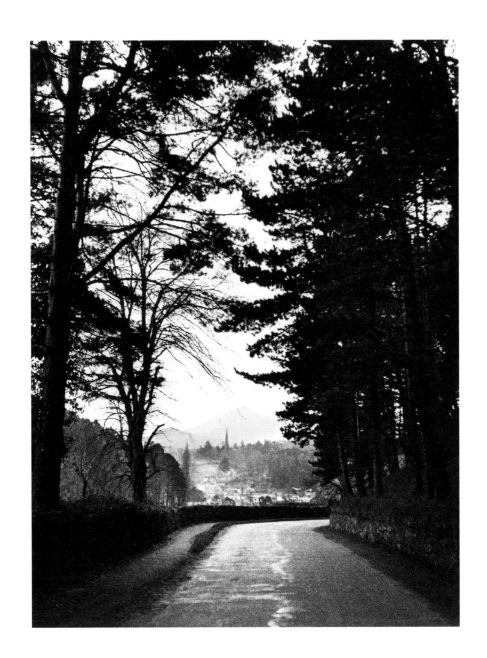

1930

Sugarloaf mountain

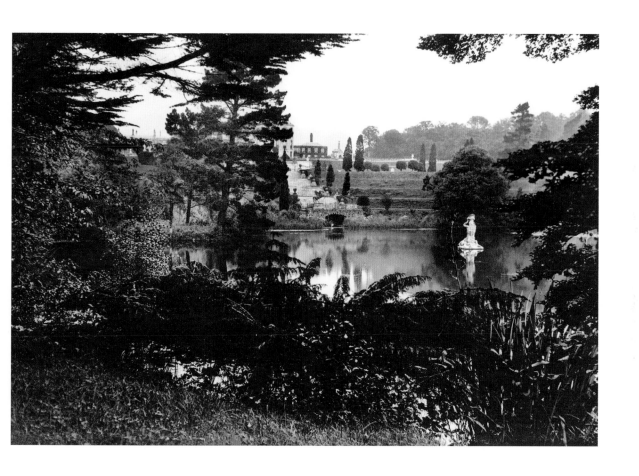

1925

Powerscourt, 'An Impression'

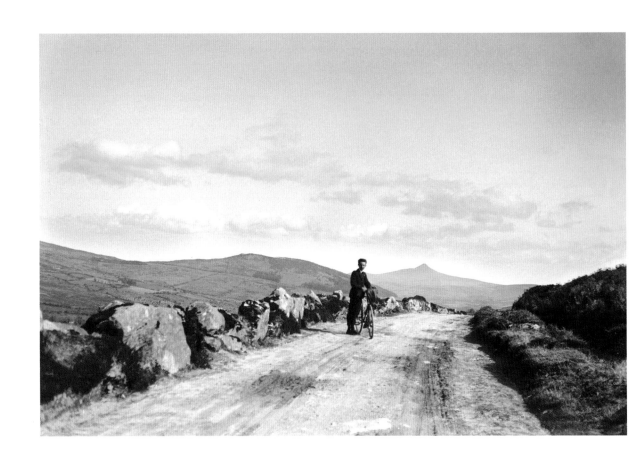

1925

Glencree Valley, on the way to Powerscourt

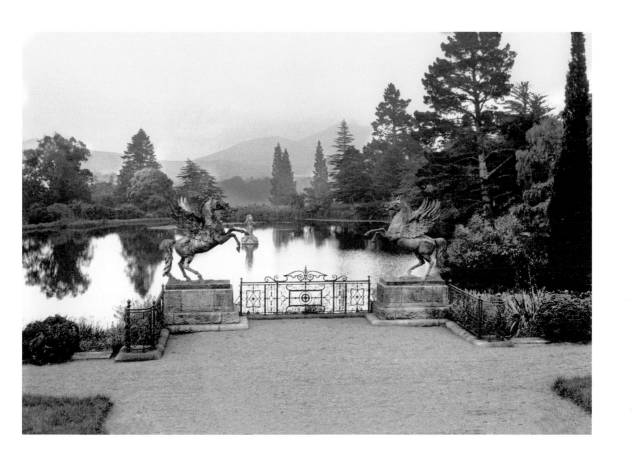

1938

Lake at Powerscourt

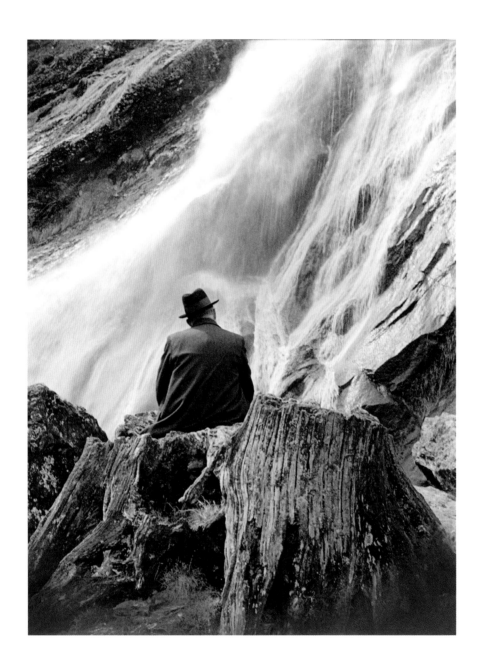

1933

Man sitting at Powerscourt Waterfall

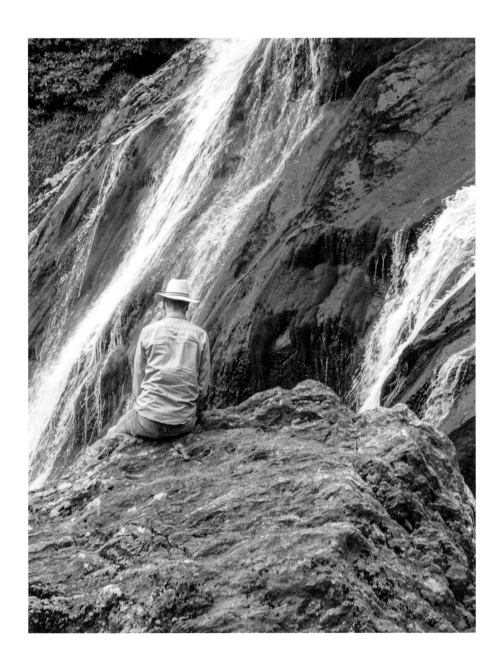

2020

Man sitting at Powerscourt Waterfall

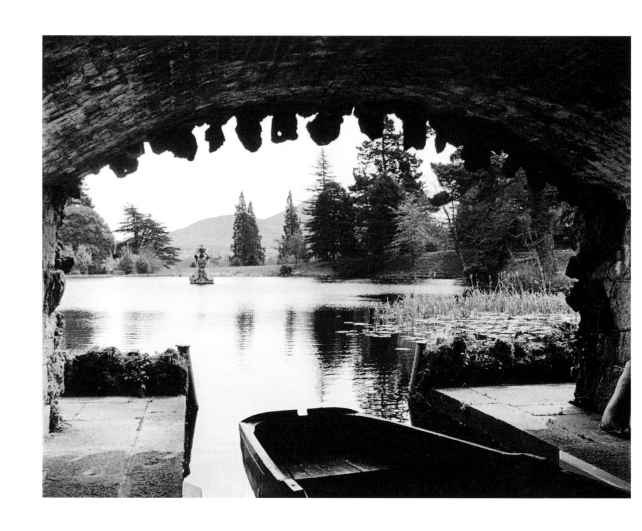

1933

Powerscourt pool

1933

The Sugarloaf mountain viewed from the Pet Cemetery, Powerscourt

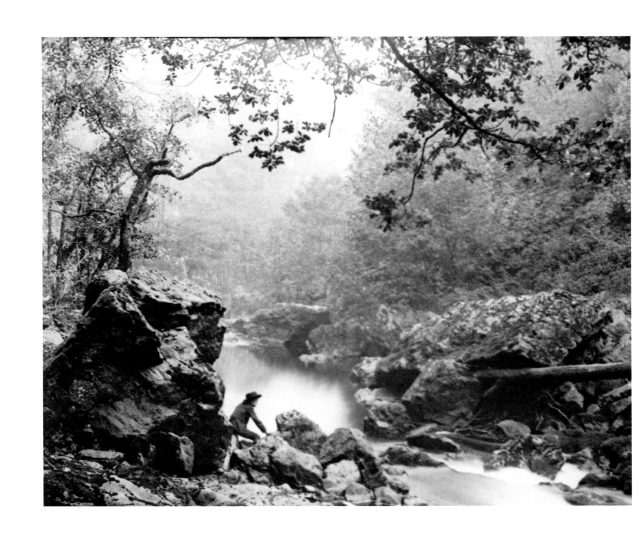

1910

Dargle Glen

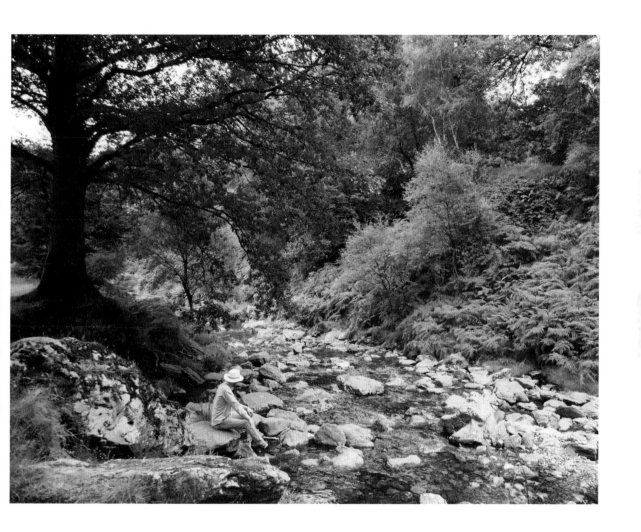

2020

Dargle Glen

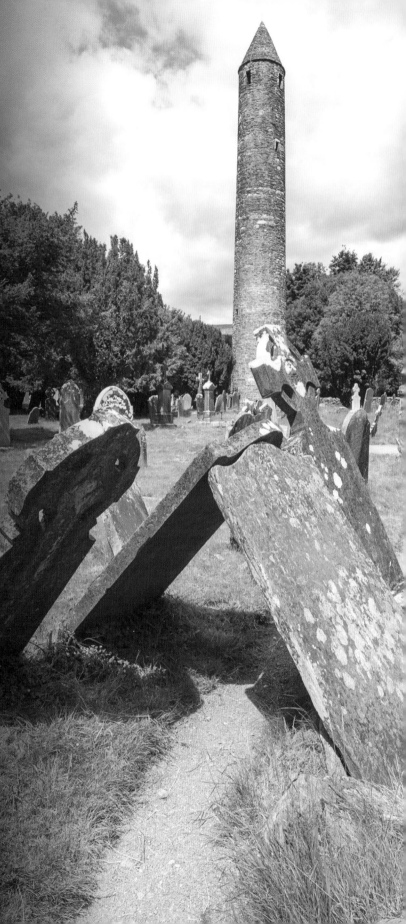

At 238 metres above sea level, Roundwood often claims to be the highest village in Ireland, although the title is much disputed. To the immediate east lies the Vartry Reservoir, the larger part of which was opened in 1863, with a second, smaller section completed 60 years later; for over 150 years it has a been major source of clean water for Dublin city and suburbs. Glendalough is situated about 10 kilometres southwest of the village. Today this is a popular destination for tourists, making it hard to believe that the first person to settle in Glendalough did so because it was so remote and isolated. Its name derived from the Irish *Gleann Dá Loch*, meaning 'Valley of Two Lakes', this was the spot supposedly chosen in the sixth century by the ascetic St Kevin to found a monastery. He is recalled here by St Kevin's Cell, the remains of a small stone structure, and St Kevin's Bed, a cave in the rock face some metres above Glendalough's Upper Lake. But there are many other religious ruins here, among them a Round Tower and the former cathedral dating from the twelfth/thirteenth centuries. The monastery at Glendalough was largely destroyed at the end of the fourteenth century but it has always remained a place of worship and pilgrimage.

Travelling a little further north, one reaches Glenmacnass, which like Powerscourt is known for a waterfall, as indicated by its name *Gleann Log an Easa*, meaning 'The glen of the hollow of the waterfall'. Set in the midst of spectacular scenery, the Glenmacnass waterfall drops 80 metres.

GLENDALOUGH

Roundwood, Glendalough, Glenmacnass, Glenmalure

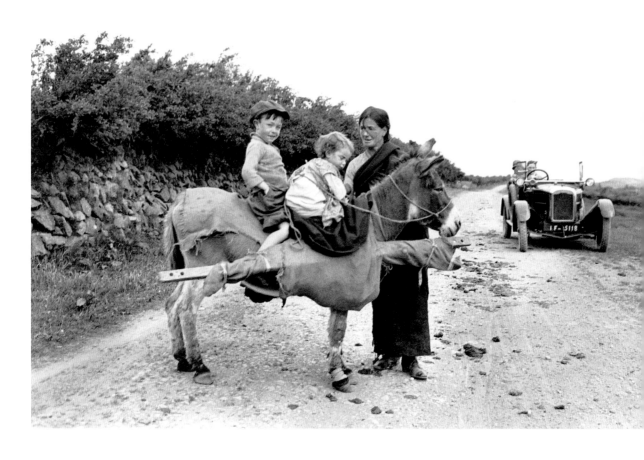

1925

An old road to Roundwood near the Deer Park

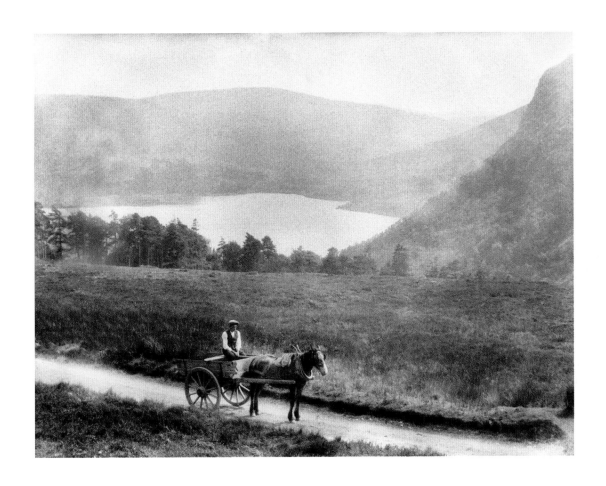

1925

Lough Tay, Roundwood

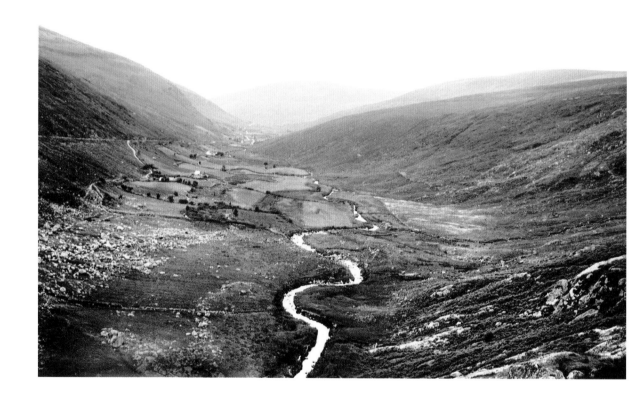

1925

From the top of the falls, Glenmacnass

2020

From the top of the falls, Glenmacnass

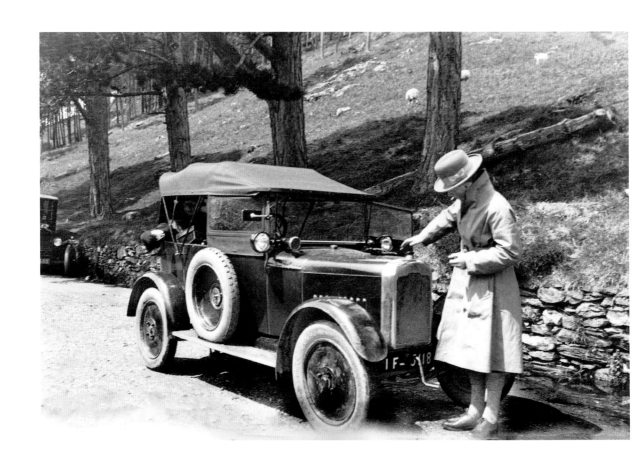

1925

A O'Leary and car, Glendalough, Wicklow, Ireland

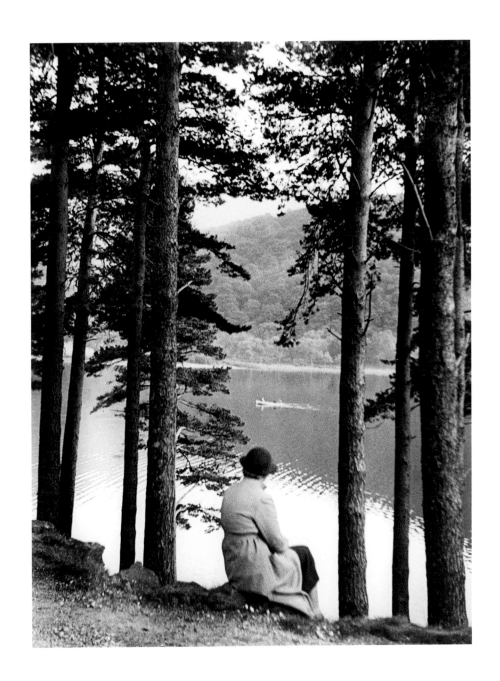

1933

Panorama with lady, Glendalough, Wicklow, Ireland

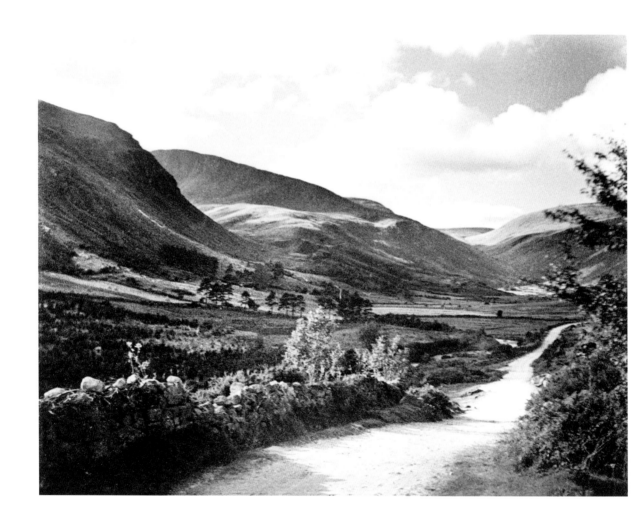

1933

Road to the Glen, Glendalough

1926

Glendalough

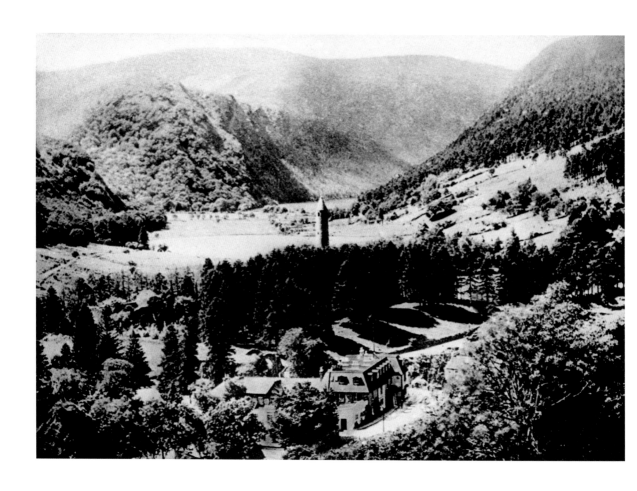

1926

Monastery Round Tower, Glendalough, with the Glendalough Hotel in the foreground

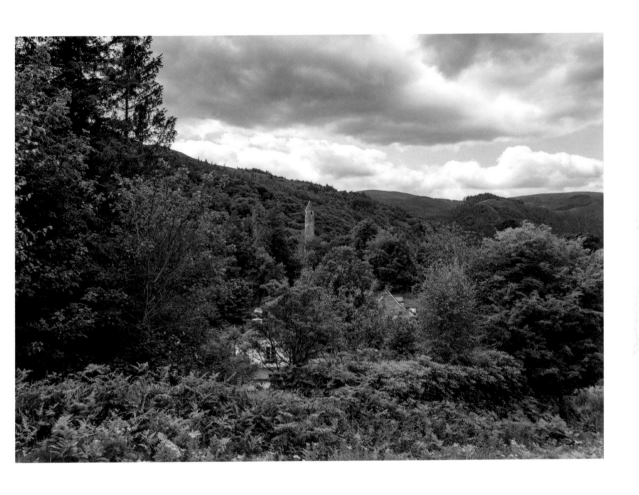

2020

Monastery Round Tower, Glendalough, with the Glendalough Hotel in the foreground

1925

Looking towards the Glen from Drumgoff Barracks, Glenmalure Hill

1925

Drumgoff Bridge and Barracks, Glenmalure Hill

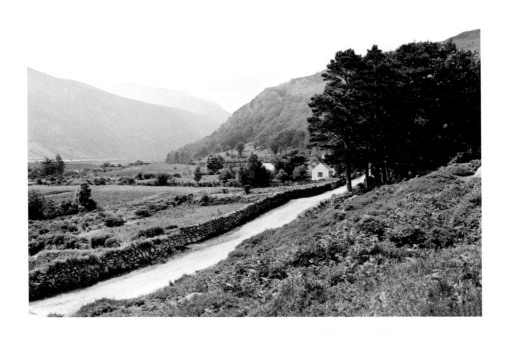

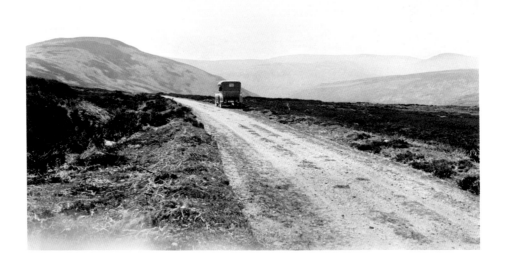

Lugnaquilla from Drumgoff, Glenmalure *Descending Glenmalure Hill*

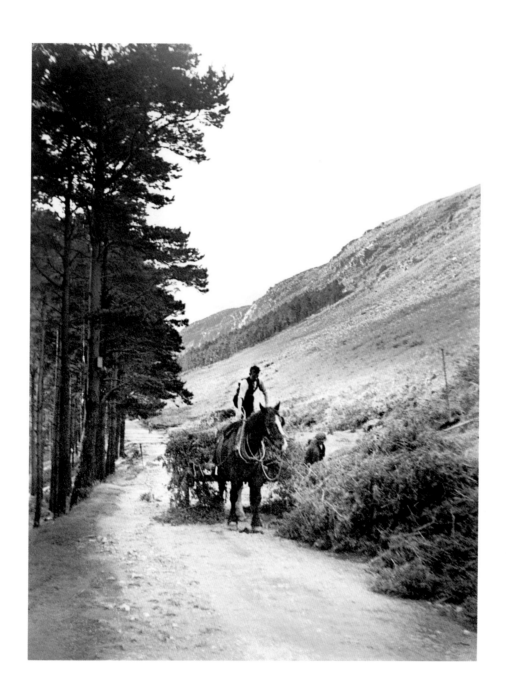

1933

Panorama with farmers, Glenmalure

Surrounded by good farmland and always a prosperous town in which fairs and markets were held, Blessington was established after 1667 when Michael Boyle, Archbishop of Dublin bought land in the area and was granted a charter by King Charles II to establish a new town here. Immediately adjacent lay a mansion he also built, Blessington House, which was destroyed in the 1798 Rebellion. Archbishop Boyle constructed St Mary's Church, still extant and completed in 1683; its tower contains the oldest complete set of church bells in Ireland. Ownership of the town eventually passed to the Hills family, Marquesses of Downshire who held it until 1908.

Covering some 5,500 acres and more than 22 square kilometres, the Poulaphouca Reservoir lies just a few miles to the south of Blessington. It was created over a ten-year period beginning in 1937 and involved the Electricity Supply Board damning the River Liffey and establishing a generating station at this point: it supplies three power stations and is one of two sources of fresh water for Dublin, the other being at Vartry (see previous section). In recent years, a greenway has been established along much of the reservoir's shores.

Further south again and situated at the end of the remote Glen of Imaal, lies the village of Donard, which derives its name from *Dún Ard*, meaning 'high fort' indicating there has long been a settlement here. Still further south and close to the border with County Carlow is another picturesque village, Kiltegan, long associated with Humewood, an elaborate neo-Gothic castle originally built in the 1870s for the Humes. They had owned land in the area since the fifteenth century and lived in their splendid home until the death of the last member of the family in 1992. It remains a private residence.

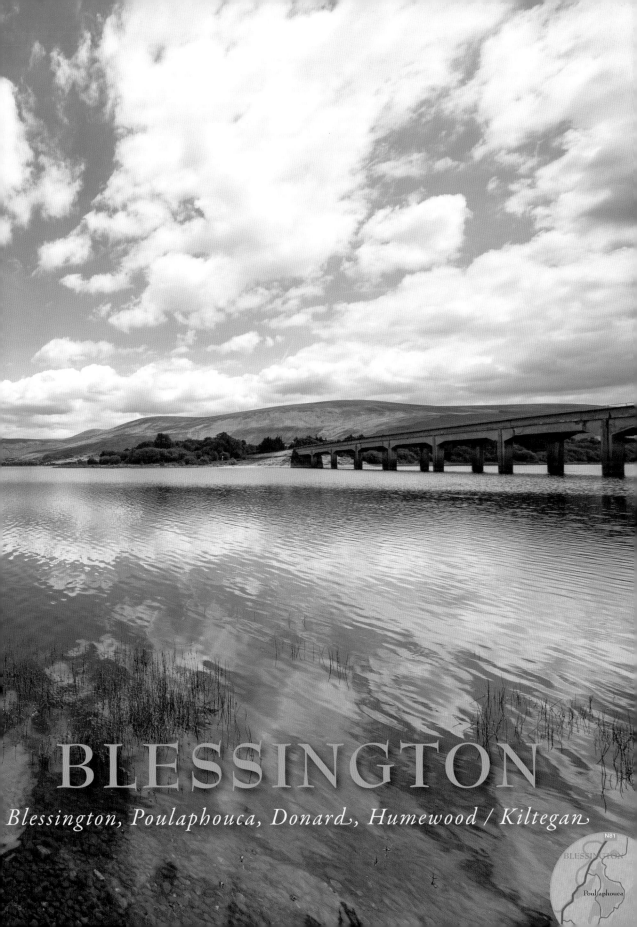

BLESSINGTON

Blessington, Poulaphouca, Donard, Humewood / Kiltegan

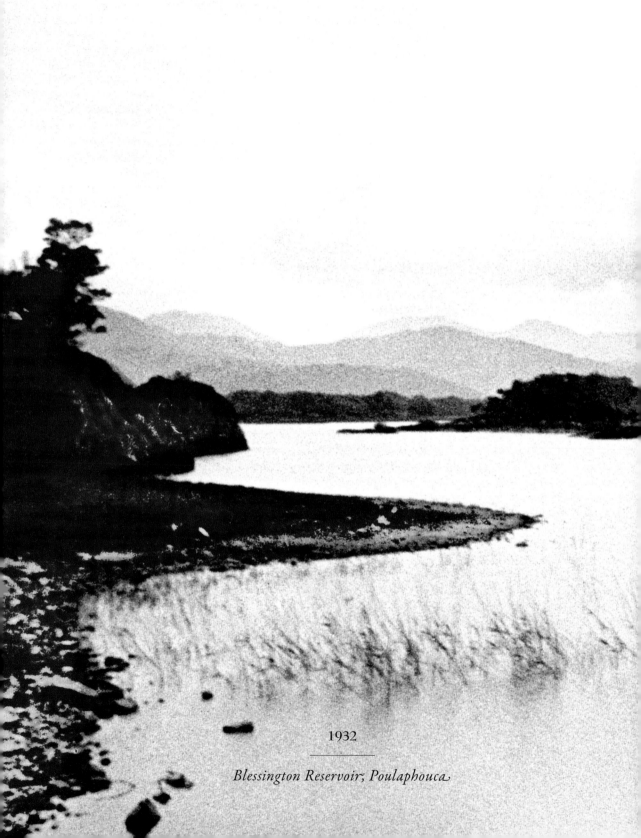

1932

Blessington Reservoir, Poulaphouca

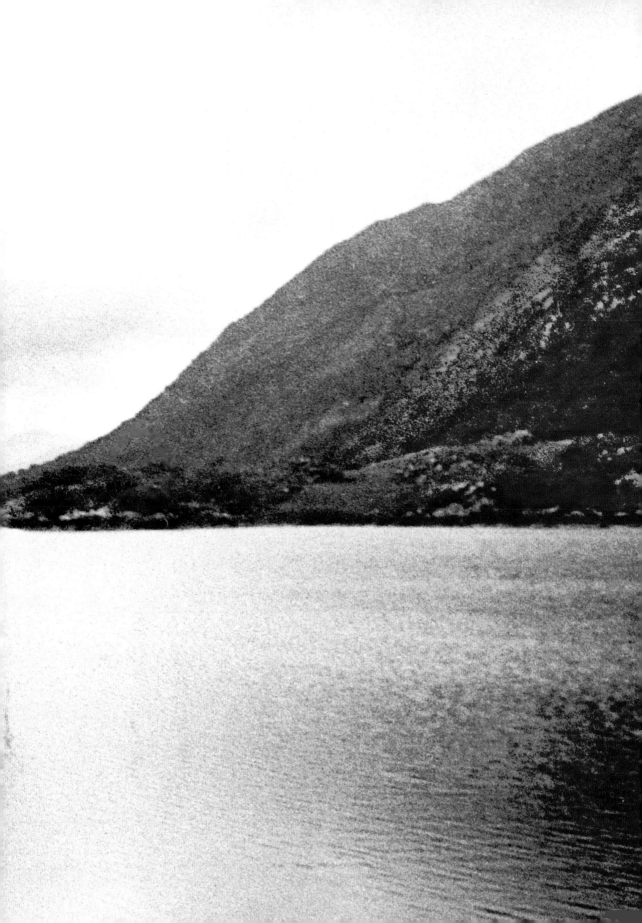

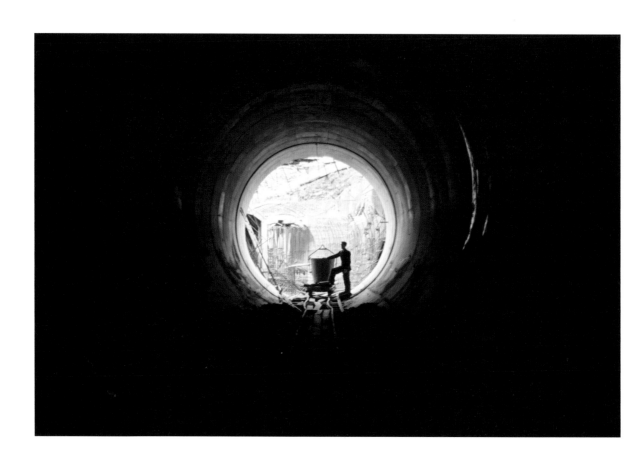

1940

Poulaphouca Dam tunnel

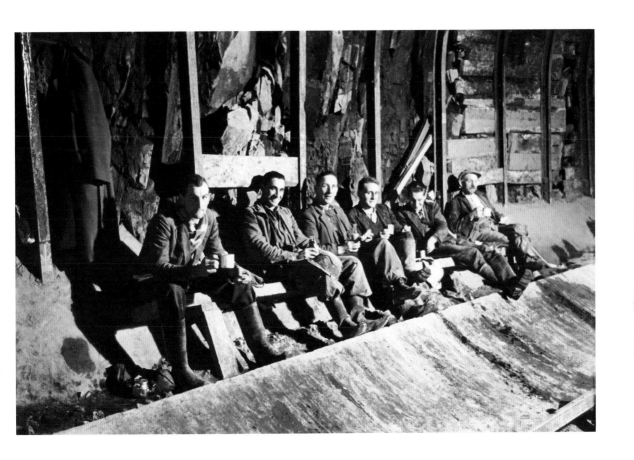

1940

Poulaphouca Dam, men taking a break

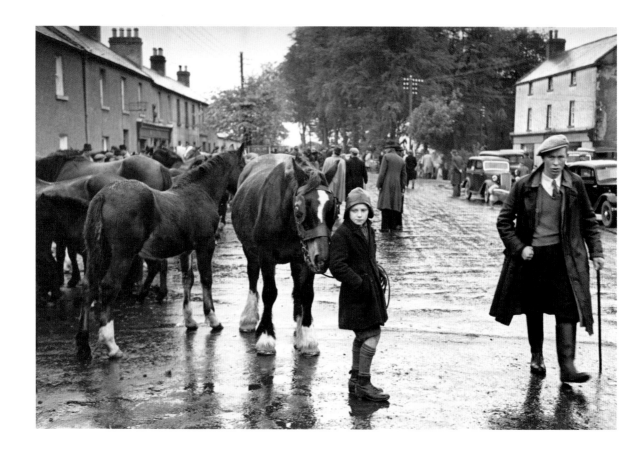

1940

Blessington Fair, Main Street, Blessington

2020

Main Street, Blessington

1928

Near Donard, women at work

1944

Children in the sunshine, Wicklow

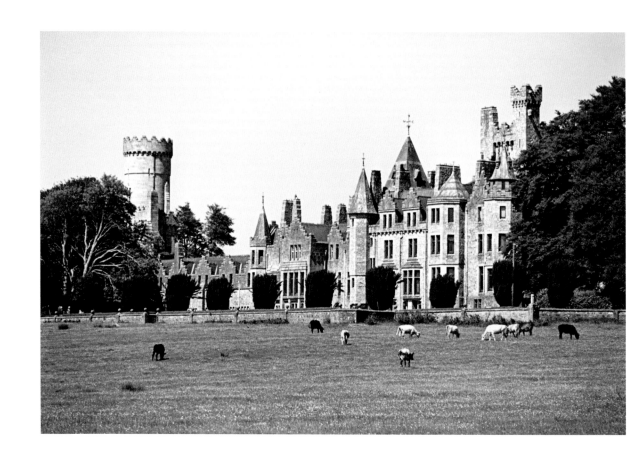

1947

Humewood Castle, Kiltegan

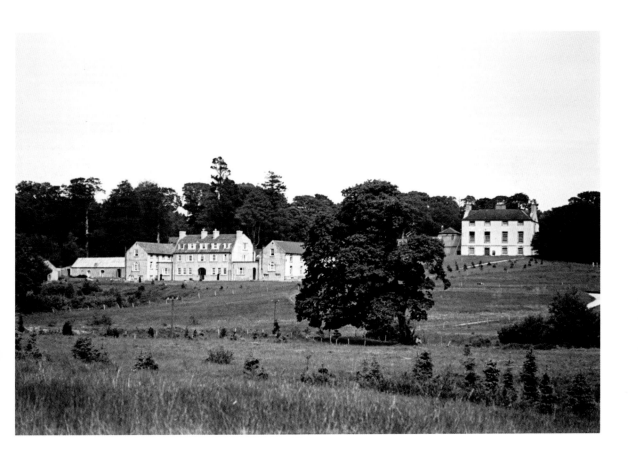

1947

High Park House, Kiltegan, once the headquarters for the Society of St Patrick for Foreign Missions

1947

Front of High Park House, Kiltegan